LANGUAGE AS OBJECT

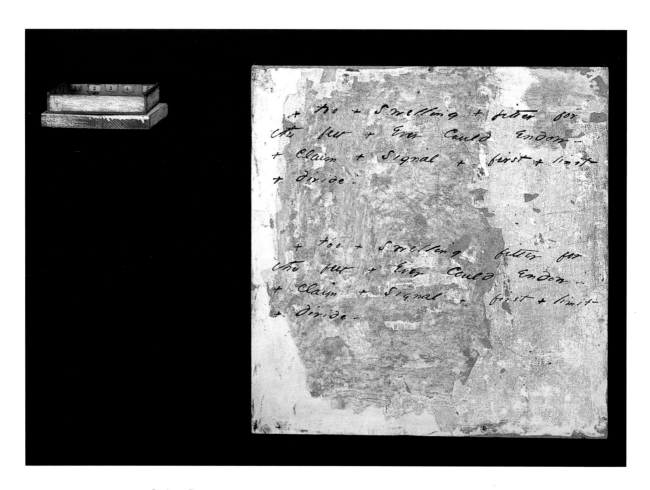

Barbara Penn
"*+ too + swelling + fitter for*"
1994 (detail)
Collection of the artist

Language as OBJECT

Emily Dickinson and Contemporary Art

Edited by Susan Danly

with additional contributions by
Martha A. Sandweiss
Karen Sánchez-Eppler
Polly Longsworth
Christopher Benfey
David Porter

Mead Art Museum, Amherst College
in association with the University of Massachusetts Press
Amherst, Massachusetts

Printed in Hong Kong
LC 96-21069
ISBN 1-55849-066-3
Designed by Elizabeth Pols
Set in Weiss and GillSans
Printed and bound in Hong Kong by South China Printing Co. (1988) Ltd.

Library of Congress Cataloging-in-Publication Data
Language as object: Emily Dickinson and contemporary art / Susan Danly, editor: with additional contributions by Martha A. Sandweiss . . . [et al.].
p. cm.
Includes bibliographical references (p.).
ISBN 1-55849-066-3 (pbk.: alk. paper)
1. Dickinson, Emily, 1830-1886—Illustrations—Exhibitions. 2. Art and literature—United States—Exhibitions.
3. Art, American—Exhibitions. I. Danly, Susan. II. Sandweiss, Martha A.

PS1541.Z5L34 1997
811'.4—dc20
 96-21069

Contents

Art Portfolio

Contributors

SUSAN DANLY
Curator of American Art at the Mead Art Museum. Danly organized the Dickinson exhibition and wrote the catalogue entries for this book. She specializes in nineteenth-century American art and photography.

MARTHA A. SANDWEISS
Director, Mead Art Museum. Sandweiss is an American cultural historian who has published widely on nineteenth- and twentieth-century American photography and the American West.

KAREN SÁNCHEZ-EPPLER
Associate Professor of English and American Studies, Amherst College. Sánchez-Eppler writes on feminism and nineteenth-century American literature.

POLLY LONGSWORTH
An independent writer, Longsworth has published numerous books and articles on the Dickinson family.

CHRISTOPHER BENFEY
Associate Professor of English, Mount Holyoke College. Benfey writes and lectures most freqently on nineteenth- and twentieth-century poetry.

DAVID PORTER
Professor Emeritus, Department of English, University of Massachusetts, Amherst. A noted Dickinson scholar, Porter has also published on the artist Joseph Cornell, about whom he writes in this book.

Acknowledgments

OUR SUCCESS in locating such a diverse array of Dickinson subjects in the complex world of contemporary visual art has depended on the knowledge and good will of the artists themselves, their dealers, museum curators, and academic scholars. We are most grateful to Will Barnet, Judy Chicago, Robert Cumming, Lesley Dill, Mary Frank, Roni Horn, Carla Rae Johnson, Paul Katz, Jerry Liebling, Aífe Murray, Barbara Penn, and Linda Schwalen who all took the time to describe how they first became enthralled with Dickinson's language and her life. Several dealers in New York and Boston facilitated further research on these artists. Jeffrey Peabody at Matthew Marks helped with Roni Horn material; Gracie Mansion Fine Arts, George Adams Gallery, and Bernard Toale Gallery assisted with Lesley Dill's work; Terry Dintenfass Gallery provided information on Will Barnet; Elena Zang Gallery arranged a meeting with Mary Frank; and Miles Bellamy at Oil and Steel Gallery discussed his ideas for a similar exhibition devoted to Dickinson and contemporary art.

Linda Hartigan, curator of the Joseph Cornell Archives and Study Center at the National Museum of American Art shared their rich resources and her own insights on Cornell's intensely personal and eccentric association with the poet's persona. Judith Hoos Fox of the Davis Museum and Cultural Center and Sarah J. Rogers of the Wexner Center for the Arts, who organized the exhibition devoted to Roni Horn's Dickinson works, graciously shared research notes and an early copy of their catalogue manuscript. Ann Sievers of the Smith College Museum of Art first drew our attention to the work of Lesley Dill and has made arrangements for the artist to participate in a Smith College Print Workshop in conjunction with the Mead Art Museum's exhibition. Photographer Nancy Burson readily accepted our challenge to "age" Emily with the assistance of a computer, further enhancing contemporary visual reinterpretations of her poetry. Professor Robert Herbert and Curator Wendy Watson at Mount Holyoke College threw more names into our Dickinson exhibition file. Ron Protas of the Martha Graham Dance Company made it possible to see archival films of *Letter to the World*, now housed in the Dance Collection of the New York Public Library at Lincoln Center. And finally Georgiana Strickland, editor of the *Emily Dickinson International Society Bulletin*, gave us access to the society's membership, which netted an even wider response among Dickinson aficionados.

In addition to the artists and anonymous private collectors who made works available for the exhibition and catalogue, the following institutions loaned materials from their collections: The Amon Carter Museum; The Grey Art Gallery and Study Center,

New York University; The Houghton Library, Harvard University; The Museum of Modern Art; The National Museum of American Art; The Smith College Museum of Art; and Yale University Library.

The exhibition has also afforded us a wonderful opportunity to facilitate "town-gown" relationships in Amherst. Numerous colleagues at Amherst College and members of the community helped to plan and implement the show and its related public programs. Dan Lombardo of the Jones Library, Mary Alice Wilson of the Five-College Public School Partnership, and Patricia Keyes and Wendy Kohler at the Mead Art Museum developed and coordinated education programs. Amherst College faculty and staff including Carol Birtwistle, Michael Birtwistle, Mallorie Chernin, Cynthia Dickinson, David Reck, and Wendy Woodson contributed their knowledge of Dickinson's work and facilitated student involvement in the project. John Lancaster, curator of Special Collections at the Frost Library, helped us to understand better the vast publishing and collecting history of Dickinson's work and Willis E. Bridegam, librarian of the college, generously agreed to loan archival material and to help provide financial support to the exhibition. The staff of the University of Massachusetts Press, especially Bruce Wilcox, made it possible to produce the catalogue. And finally we would like to acknowledge the efforts of the Mead Art Museum's staff: Linda Best, Irene Farrick, Tim Gilfillan, and Lois Mono. Without their hard work and cooperative spirit, we could not have fully realized this project.

While the exhibition and its public programs represent the creative efforts of all of these people, it is the financial support of the National Endowment for the Arts, a federal agency, Massachusetts Foundation for the Humanities, the May H. and Albert M. Morris, Class of 1913, Fund from the Frost Library at Amherst College, and the Hall and Kate Peterson Fund from the Mead Art Museum that ultimately made our efforts visible to the public. This generous level of funding made it possible for the museum to invite writers on the humanities, as well as art historians, to shape the scope of this endeavor. We would like to thank Karen Sánchez-Eppler, Christopher Benfey, Polly Longsworth, and David Porter, not only for their written contributions to the catalogue, but for their advice on the conceptualization of the exhibition and programs. To quote the poet, this is our collaborative "letter to the World."

Martha A. Sandweiss
Susan Danly

Foreword

The Poet's Resonance

THERE IS NO ESCAPING IT. Amherst, Massachusetts, is Emily Dickinson's town. The poet's face stares out from the book covers placed in shop windows, a sign in front of her home promises tours, the annual pilgrimage to her grave on the anniversary of her death attracts the faithful from around the world. Few American writers are so inextricably linked to their hometowns. But instead of deflecting curiosity about her life, Dickinson's reclusiveness magnifies it. There is an intense interest in the physical place where she lived and worked, as if walking the streets of Amherst or standing quietly for a few moments in her bedroom can explain the many mysteries of her life or the genius of her poetry.

Amherst College's connection to the Dickinson family stretches back to the institution's very beginnings. The poet's grandfather, Samuel Fowler Dickinson, was a founder of the college in 1820 and a member of its first board of trustees. Emily's father, Edward Dickinson, became treasurer of the college in 1835, and worked in that capacity for thirty-seven years. A year after Edward's retirement, his job passed to his son, Austin, the poet's brother, who served the college for twenty-two years more.

Emily Dickinson—disqualified by her gender from attending Amherst College herself—lived on the periphery of college life, taking advantage of the social and intellectual opportunities that the college offered to residents of the small, largely rural town. The family homestead where she was born in 1830 was just two blocks from the campus. Students and faculty members were frequent visitors to her girlhood home and to the house farther north in Amherst where she lived from the age of ten until twenty-four. The college libraries, natural history cabinets, public lectures, and social events remained an important part of her life after she returned to live at the homestead in 1855. After 1865, when she grew increasingly reclusive, her involvement with college life became more vicarious; she kept up with college news through friends, as well as through her father and brother, whose daily work immersed them in college affairs.

Amherst College and the Dickinson family remain connected, more than 110 years after the poet's death. The college owns the family homestead and opens it for public tours that include the intensely private bedroom where Dickinson wrote so much of her verse. The college library holds a large collection of Dickinson's manuscript poems and letters, along with such ephemera as a curling lock of the poet's auburn hair. It is the repository, too, for the daguerreotype of the adolescent Dickinson that is the only known photograph of this camera-shy woman.

Because the Mead Art Museum serves the town of Amherst as well as Amherst College, it is perhaps only natural that many artists, collectors, and dealers should have imagined it as a place for works of art relating to Emily Dickinson. In recent years, any number of artists have approached the museum asking to exhibit their Emily Dickinson pictures. A

handful of collectors and dealers have approached us as well, convinced that they had unearthed important new photographs of Dickinson. (None, unfortunately, seems persuasive when compared directly to the known daguerreotype). Rather than dealing with the artists and collectors one by one, it seemed worthwhile to step back, look at the big picture, and ask some broader questions about the artistic interest in Dickinson's work. In what ways did artistic responses to Dickinson's work mirror contemporary critical thinking or the literary responses of contemporary poets? Could artistic responses to the poet's work suggest new ways of thinking about the poems themselves?

Such questions and numerous scribbled references to Dickinson-inspired artists sat in a museum file until Susan Danly joined the staff as curator of American art in 1993 and leapt at the challenge of searching for answers. The range, quality, and perceptiveness of the work she found surprised and delighted us, and we decided to do an exhibition and catalogue that would present the work and explore the many issues it raised about the interconnection of the visual and literary arts.

Happily, Amherst is the home not just of Dickinson memorabilia but of many distinguished Dickinson scholars who agreed to help us with this project. Literary scholar Karen Sánchez-Eppler, associate professor of English and American studies at Amherst College, writes here on the connections between the changing critical perceptions of Dickinson and the visual art created in response to her work. Dickinson biographer Polly Longsworth explores the ways in which the single daguerreotype of the poet's face has affected popular thinking about her and her work. Writer Christopher Benfey, associate professor of English at Mount Holyoke College, surveys the impact of Dickinson's poems on subsequent generations of poets. Susan Danly writes on individual artists and their specific debts to Dickinson, with assistance from David Porter, professor emeritus of English at the University of Massachusetts, Amherst, who contributes a short essay on the connections between Dickinson and artist Joseph Cornell.

This catalogue, we hope, will not only introduce new works of art but also raise broader questions about the interaction of literature and the visual arts. Stretching beyond simple illustration, the art works represented here engage the literary and cultural issues raised by Dickinson's poetry and the particular circumstances of her life. Using a distinctly modernist idiom, the artists considered in this catalogue recover the resonance of nineteenth-century ideas and reassert the power of art as critical commentary. They prove to be not just perceptive observers of the material world, but astute readers as well.

Martha A. Sandweiss, Director, Mead Art Museum
Amherst College, Amherst, Massachusetts

ESSAYS

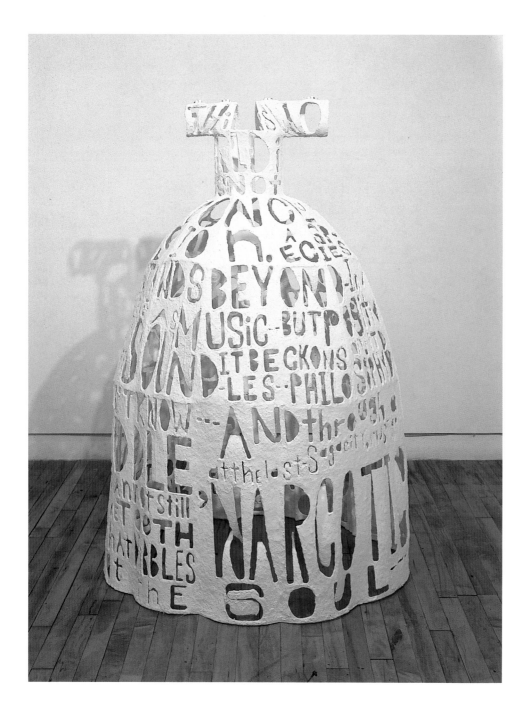

Plate 1

Lesley Dill

White Poem Dress, 1993

Painted metal and plaster

Private Collection

Exhibiting Sheets of Place

Seeing Emily Dickinson through Contemporary Art

Karen Sánchez-Eppler

B LUE PLASTIC LETTERS set in shining aluminum cubes scatter around the edges of the floor spelling out "MY BUSINESS IS CIRCUMFERENCE." A white dress is carved with words. Frozen by the camera in a full white skirt against the blackest ground, Martha Graham kicks. A square of blue glimmers out of the birdcage enclosure of a box. Hidden beneath banistered stairs, a volcano erupts. Over the last fifty years American artists have created these objects in response to the poetry of Emily Dickinson. They are neither sentimental nor pretty. Viewers who envision Dickinson offering two daylilies as her "introduction" to her literary "preceptor" Thomas Wentworth Higginson, or who know that Dickinson's first editor, Mable Loomis Todd, stamped the cover of her poems with a delicately blooming Indian pipe, may be surprised to find that there are few flowers here. The familiar signs of quaint strangeness—a poet dressed in white, cloistered in her father's house—are treated as neither quaint nor merely odd. Instead they appear in this exhibition as marks of isolation, power, longing, and subterfuge, the necessary strategies for modern artistic practice.

The events of Dickinson's life are few and simply told. Born 10 December 1830, into a prominent Amherst family, Emily Dickinson was schooled at the Amherst Academy and for one year at Mount Holyoke Female Seminary; she had an active, intellectually stimulating girlhood, and many close friendships, which are richly documented in her witty and affectionate letters. She seems to have suffered an emotional crisis in her early thirties, the subject of much and varied biographical speculation. This "terror since September," as she called it, coincided both with the Civil War and with her most intense period of poetic production.[1] During this time Dickinson gradually withdrew from external activities; the "Queen Recluse" of legend, she confined herself to the Dickinson Homestead, to her books, her family, a few chosen visitors, and a larger circle of correspondents.[2] It is a life that we find hard to grasp because of its sparseness, and therefore Dickinson is often patronized or pitied. Yet this paucity of outward event provided Dickinson with rich opportunity for skeptical observation and passionate emotion. As the art assembled for this show amply attests, this is not a life of pathetic or charming smallness, but rather a life of bare essentials, a life pared down to the stark conditions of feeling, thought, and artistic vocation.

In eschewing the sweet and sentimental, the works exhibited here reveal the iconoclastic, rigorous, self-conscious poet contemporary critics have found in Dickinson. There are specific critical debts: Joseph Cornell's assembling his Dickinson boxes while his friend Jay Leyda assembled his compendium of Dickinson's life, the log book of diary entries, marginal doodles, letters, playbills, recipes that make up *The Years and Hours of Emily Dickinson*; Barbara Penn's creating "*+ too + swelling + fitter for*" after reading

Susan Howe's discussion of how these poetic variants swell in excess at the end of a Dickinson poem.[3] I am a literary critic, not an art historian, and for me one goal and pleasure of this exhibition lies in inverting this chain of influences to ask not how Dickinson's poetry and critical interpretations of it have prompted this art, but rather how this art can help us see Dickinson and her poetry differently.

Dickinson's readers have always found her poetry unsettling and confusing. "All men say 'What' to me, but I thought it a fashion" (L 271), Dickinson replied in exasperation when Higginson wrote of his difficulty in understanding her poems. After reading his "Letter to a Young Contributor" in the *Atlantic Monthly* she had written to him in April 1862 to ask whether this arbiter of literary taste could "say if my verse is alive" (L 260). His responses burgeoned into a lifelong correspondence, but they also confirmed Dickinson in her conviction not to have her poetry printed and sold. Ten poems were published during her lifetime, most altered to conform to editorial standards of prosody, rhyme, and punctuation, all but two printed without her permission. Instead of publishing, she disseminated her poems through letters and copied them into her own hand-sewn volumes—the small manuscript books Dickinson scholars refer to as her fascicles. In this circumscribed model of publication the "Whats" were fewer and tempered by intimacy. Still, even her sister, Lavinia, was surprised to discover, after Emily's death in 1886, the vast scope of Dickinson's poetic production. We now count 1,775 poems, almost half of them apparently written between 1860 and 1864. The early editions brought out by Higginson and Todd in the 1890s were regularized so as to seem less strange—providing titles, smoothing rhyme schemes and meter, and substituting what Higginson called more "sensible" metaphors. Only in 1955, when Thomas Johnson produced the three-volume variorum edition of Dickinson's poems, were her patterning of dashes, capital letters, and half rhymes allowed to stand without "correction." Thus in some ways Emily Dickinson is a modern poet, her poetry only becoming readable in the later half of this century. Indeed, critics argue we may not yet have recognized the full extent of Dickinson's textual radicalism; in his own way Johnson also regularized her verse by removing it from the sequences that she created in her manuscript books and thus reduced her oeuvre to a succession of single lyrics, by presenting her variant wordings as neatly coded and excisable addenda rather than as integral parts of her poetry, and by arranging her irregular manuscript line breaks into more conventionally shaped stanzas. In all these ways we are still saying "what" to her poetry, still trying to figure out how to read her. Much of the contemporary art collected in this exhibition and pictured in this catalogue provides provocative instances of rereading Dickinson.

The works exhibited here do not illustrate Dickinson's poems. Lesley Dill calls her sculptures and photographs "collaborations" with Dickinson and this may well be the best way to understand the complex, reciprocal relations that characterize all the pieces in this show.[4] More than interpret her life and poems, they translate—transporting an idea, an expression from the medium of the written word to other forms and other materials. In such a move, of course, everything changes. Materializing her poetics, these works make palpable a condition of writing that constantly fascinated Dickinson: her poetry is largely committed to the effort of providing abstract ideas and emotions with an apprehensible form. Dickinson interrogates the relation between the abstract and the concrete, and in this project she finds language an unstable medium, since words both are, and are not, objects.

In many ways the poems of Emily Dickinson seem a frustratingly bad source for the visual artist. Dickinson's poetry is not visual in any conventional sense; she does not paint scenes with words. Indeed her poems thrive on dissolving images, not forging them. In her piece "When Dickinson Shut her Eyes," No. 974, Roni Horn casts Dickinson's poems into long aluminum blocks—one line for each block—and then, in a casual and haphazard array, leans these staffs of words against each other and the wall (fig. 1). I have taken the title of my essay from a poem that Horn has remade into sculpture:

> The Soul's distinct connection
> With immortality
> Is best disclosed by Danger
> Or quick Calamity—
>
> As Lightning on a Landscape
> Exhibits Sheets of Place—
> Not yet suspected—but for Flash—
> And Click—and Suddenness.
>
> (P 974)[5]

This poem cares about connections; it wants to describe the specificity of the soul's link to the unknowable realm of immortality, but even more it demonstrates the poet's relation to such intangible subjects. How can such connections be disclosed, how can the poet understand them, how can she make us see them? For Dickinson the goal here is visual, but the only act of seeing she depicts happens within a simile. We glimpse the soul's connection to immortality the way we see things in a lightning storm. Rather than the details of any individual landscape—the precision of seeing that would make meaning distinct—we get "Sheets of Place," the sense of locality stripped of all the particulars of location. We may well take an image from this poem, the image of a lightning flash. But this is not the image the poem had set out to disclose; lightning is only an illustration of something else, and Dickinson's description quite consciously disrupts even our capacity to see this exemplary flash. On the bottom of her manuscript for this poem, Dickinson offered variant words for *flash* and *click*: *fork* and *bolt*. *Flash* and *click* describe the suddenness—the time—of lightning, only the suppressed, marginal words, *fork* and *bolt*, tell its shape.

Roni Horn's sculpture makes reading hard, the vertical lines of letters running in different directions, sometimes reversed, sometimes hiding one another. But Horn makes the formal structure of the poem immediately visible: what we see with light-

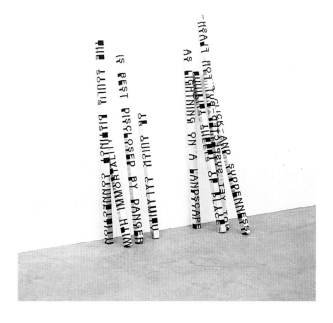

Figure 1

Roni Horn
When Dickinson Shut Her Eyes—No. 974, 1993

Plastic and aluminum

Matthew Marks Gallery, New York

ning clarity and rapidity is that this piece has two sets of four-lettered staffs—that the poem has two stanzas. Horn often works with doubling. Her series "Things Which Happen Again" displays pairs of solid copper objects and therefore, as Horn explains, each object "actively refuses the possibility of being experienced as a thing in itself."[6] In pairs, objects undermine each other's singularity. There is no uniqueness, only redundancy. Critics have often complained that Dickinson's two-stanza poems have this effect, the second stanza thwarting the aphoristic certainty of the opening lines, as, in this poem, the assurance of "best disclosed" is lost in an explanatory image that ends up seeing without disclosing any particular scene or image. Horn's art displays what she and Dickinson share, the recognition that it is possible to separate vision from image, to see without seeing any specific thing.

In a parallel linguistic version of this insight, Dickinson once remarked that "subjects hinder talk." Dickinson's resistance to subject matter, her habit of reducing images to examples and analogies, stands at odds with traditional notions of visual representation. The critic Robert Weisbuch explains the process of her "analogic" and "sceneless" poetics: "Most often the boundary of a Dickinson poem is not a particular scene or situation but the figure of the analogy as it moves from scene to scene. Dickinson gives us a pattern in several carpets and then makes the carpets vanish."[7] But how do you paint carpets as they vanish? Will Barnet's canvases attest to this difficulty. In Barnet's Dickinson series, the image of the poet's face predominates. His depictions of her are loosely based on a daguerreotype taken when she was sixteen (see pl. 2); the only known portrait of her as an adult, it poorly approximates the poet during the "flood years" of her productivity in her thirties. Thus in Barnet's work the image of the writer, of whom we do have at least this one inadequate image, serves to organize the fleeting imagery of her poems. When his pieces do focus on an image from one of her poems the effect is disquieting—a startling reification of imagery that, within the poem, refuses all such solidity (fig. 2).

When Night is almost done—
And Sunrise grows so near
That we can touch the Spaces—
It's time to smooth the Hair—
And get the Dimples ready—
And wonder we could care
For that old—faded Midnight—
That frightened—but an Hour—
(P 347)

The sky in the corner window grows light, the one place of strong color amidst the browns and grays of woman and room. But the act of smoothing hair, a brief detail in the poem, a way of preparing for the onslaught of time, here expands to become emblematic of the poem's more formless concerns with daily cycles, fear, and the capacity to forget and to carry on. To view painting and poem together is to witness the fragmentary act of focus required to wrest images from Dickinson's writing.

The images Mary Frank cuts into flat sheets of paper can only be seen when light shines through the slits; without light the paper becomes flat and empty, the images

vanish. Thus the "shadow papers" that Frank has made to accompany an anthology of Dickinson's nature poetry replicate the transient quality of the imagery in these poems. Frank describes her process this way: "They're pieces of paper that are cut with a scissors. I hold them up to the light and cut freely—it's a kind of dance with the paper. I try to find forms and create space without cutting anything out of the paper."[8] Her goal is to make shapes distinguishable without making them fully separate, without removing them from the sheet of paper with which she began her scissor dance. Because of her reliance on light to make visible the forms in her shadow papers, Frank's work appears particularly apt in relation to Dickinson's many poems that strive to describe the effects of light.

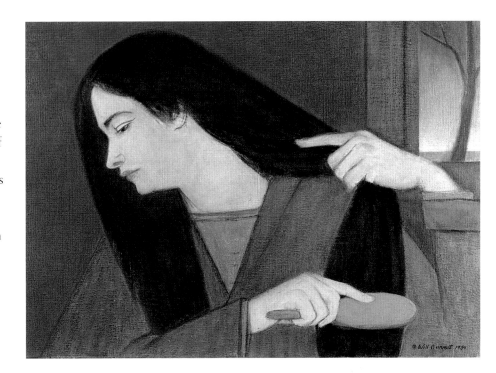

Figure 2

Will Barnet
Combing, 1990
Oil on canvas
Collection of the artist

> Blazing in Gold and quenching in Purple
> Leaping like Leopards to the Sky
> Then at the feet of the old Horizon
> Laying her spotted Face to die
> Stooping as low as the Otter's Window
> Touching the Roof and tinting the Barn
> Kissing her Bonnet to the Meadow
> And the Juggler of Day is gone
>
> (P 228)

In this poem, metaphors for the setting sun jostle each other with wild abundance: fires blazing and quenching, leopards leaping and dying, a woman in a bonnet, the juggler of day, all flash vivid presence and disappear. In the playful excess of these rapid progressions there is no need to worry about the lady meeting the leopard. This panoply of imagistic conjurings do, of course, evoke a specific scene. But I would argue that this poem tells less about a sunset than it does about the act of seeing: at once fecund and ephemeral. Thus all the verbs that swirl through this poem—blazing, quenching, leaping, laying, stooping, touching, tinting, kissing—cannot erase the absolute infinitive of "to die" or forestall the end where all "is gone." In Frank's shadow paper accompanying this poem, the light pouring through her scissored lines creates the horizon, distinguishing sky mountain

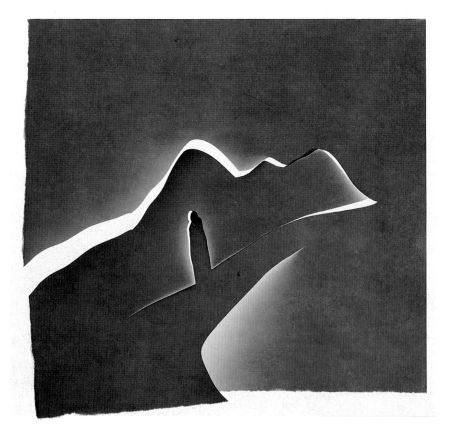

Figure 3

Mary Frank
Person and Mountain,
1994

Cut paper

Elena Zang Gallery

and earth (fig. 3). In order to emphasize these lines, Frank splays the cutout more radically in this piece than in any other in the series, expanding the intersticial light-line into a wide band of illumination and disrupting the regular rectangle of the paper. If this splaying increases the light, it also increases the precariousness of those lines, as the misaligned sheet threatens to square itself. Frank cuts also one figure: the woman who watches the light. The imagery of sunset, the forms in the page, are products of perception, made by the seer. But the seer is never fully separable from the external world she sees; her form emerges precariously from it and remains always on the verge of being absorbed back into it. Just dim the light and the woman will blend into ground and mountain, the horizon merge with sky, the page appear blank, suddenly sceneless—"And the Juggler of Day is gone."

Barbara Penn approaches the problem of visually representing sceneless poetry somewhat differently—neither freezing one of Dickinson's fleeting images nor constructing pieces that embody the transience of vision but rather creating objects and referents to anchor Dickinson's words. In one piece she collaborates with a Dickinson poem that begins "After great pain, a formal feeling comes" (P 341) by filling an infant's crib with orderly lines of eggs that hatch an array of strange natural objects (fig. 4). The crib stands on a platform in front of a wall covered with raised half-spheres that evoke both eggs and breasts. In Dickinson's poem, the great pain and its aftermath are described in precise detail, but, characteristically, the source of that pain remains unspecified and mute; there is no mention of childbirth, cribs, suckling. Penn has chosen to ally that unnamed pain with the act of creation—the labors of birth and artistic making. In so doing she provides a material form and a specific female experience for what in Dickinson's own account remains unsaid. That she chooses to represent here a particular pain, a kind of birthing, that she knows Dickinson has not experienced, demonstrates how the act of interpretation inserts something foreign into the poem. Penn's piece does not claim to represent Dickinson's poem transparently , but instead emphasizes the differences between what Dickinson writes and how Penn reads it. Dickinson's poem acknowledges how pain and the numbness that follows it eradicate the relevance of reasons and explanations, but Penn reminds us that in order to grasp such internal

experiences we must ground them in our individual histories of pain. Thus the crib does not so much explain Dickinson's poem by granting it an image, as offer this image as Penn's personal imagining of Dickinson's "After great pain."

I am not arguing that Dickinson's is an antivisual poetics. Her poems are full of visual details—often miraculous in their economy and precision. If there is no actual lightning, no woman with a brush, no leaping leopards, if these images represent not themselves but something else for which there may be no image, this need not detract from their vividness. Poetry, even in its more conventionally imagistic forms, asks us to see something that is not actually present at our moment of reading. These conjuring tricks, Dickinson's extremely unstable use of imagery reminds us, are the writer's work, words striving to give presence to what is absent. One can get caught in one's own tricks, however, and if what lingers with us from Dickinson's poems is often the very imagery she does so much to undermine, this is because images prove obdurate. They have a sensual immediacy that inhibits our attempts to see through them to some abstraction beyond.[9]

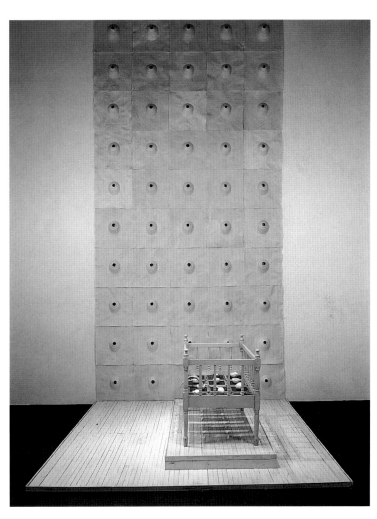

Figure 4
Barbara Penn
Poem No. 341 "After great pain, a formal feeling comes," 1994
Mixed media installation
Collection of the artist

Dickinson strives in her poems to grant the physical resistance and tenacity characteristic of imagery to abstract ideas themselves, to produce with her poems a topography of emotions and ideals. In the poem Barnet represents through the smoothing of hair, Dickinson makes dawn not temporal so much as spatial and tangible, claiming "Sunrise grows so near / That we can touch the Spaces." So she writes of "A nearness to Tremendousness" (P 963), implying that awe physically occupies space, or calls the period "After great pain" "the Hour of Lead" insisting that time has weight, or explains in an early letter to Higginson that "My Business is Circumference" (L 268), suggesting that the poet's work is to survey the rim of experience, to define its contours. Dickinson's rejection of the traditionally imagistic in no way diminishes her desire to endow language with much of the sensuousness and immediacy usually associated with physical objects. In this sense Dickinson proves less a visual than a spatial poet and much of the best contemporary work on Dickinson is sculptural.

Joseph Cornell's evocation of Emily Dickinson in *"Toward the Blue Peninsula"* reflects her knowledge of how desire structures space (see pl. 6). Cornell made this box in the 1950s. The poem from which he drew this phrase had been published in its

entirety only fifteen years earlier, in the 1935 *Unpublished Poems of Emily Dickinson* and was far better known as the one-stanza excerpt that early editors had entitled "Philosophy." In the 1896 edition of Dickinson's *Poems* the excerpted stanza-poem appears with punctuation and capitalizations neatly regularized:

> It might be easier
> To fail with land in sight,
> Than gain my blue peninsula
> To perish of delight.
>
> (P 405)[10]

It is likely that this is as much as Cornell knew of the poem. Indeed, as David Porter suggests, he may not even have known this much, but only the phrase "blue peninsula," which appears without poetic context in a passage Cornell copied out of Rebecca Patterson's *The Riddle of Emily Dickinson* (1951).[11] In any case, the box that bears this title uses a square of blue—an open window—to create a sense of distance, a space of delight seemingly outside the wood and wire-mesh birdcage enclosure of the box. Robert Lehrman explains that the wire-mesh that frames the window is bent so as to cast "two shadows on the back of the box and the sky beyond. One appears as a rectilinear grid which suggests the cartesian coordinates from which we map our destinations. The other appears to recede in space evocative of the mystery of that which we cannot know." Thus the fall of light reveals that even the grid of a cage may be multiple, ambivalent. The bird of this cage has departed, leaving only two shreds of paper on the box floor to "echo the small scraps of paper on which Emily Dickinson wrote her poems."[12] The poem as a whole proposes that if loneliness were to end, it

> Would interrupt the Dark—
> And crowd the little Room—
> Too scant—by cubits—to contain
> The sacrament—of Him—
>
> (P 405)

The mention of cubits, of a room that crowds, presents isolation and longing as architectural problems. The brilliance of Cornell's box lies in its capacity to create the feeling of distant space out of a single flat square of blue. Like Dickinson, Cornell would make distance out of paper and space out of scant confines.

Critical work on Dickinson in the last few years has itself come to emphasize the material and spatial aspects of her poetic production. Renewed focus on the problems of editing has led critics to think of the manuscript-books—leaves of folded stationery that Dickinson stacked and sewed together, creating forty small fascicle volumes of her poems—less as texts waiting to be published than as themselves carefully crafted things. Jerome McGann places her manuscript-books in relation to modernist concerns with how words look on the page, likening her creation of these volumes to the work of William Morris's Kelmscott Press, with its marginal decorations and carefully chosen type. Confronted with these manuscript volumes, editorial dilemmas abound: What to do with the variant wordings that Dickinson left on these pages? What to do about her

line breaks that in manuscript fracture the conventional stanzas editors have produced? What to do about the variety in length and shape of her famous dashes? The list goes on and on. Susan Howe, celebrating the artistry of Dickinson's manuscripts, notes how in "The Sea said 'Come' to the Brook" Dickinson drew the poem's many S's so that they look like waves rolling down the page (see pl. 3). "Maybe," she concludes, "the poems must really be experienced as handwritten productions—the later ones as drawings."[13] Judith Farr discusses Dickinson's own pencil drawings and notes how in both letters and poems she used painting as a "systematic metaphor for writing."[14]

Barbara Penn's assemblages of found objects and facsimiles of Dickinson's manuscripts literalize what it would mean to look at these pages as a form of visual art. In her version of "The Sea said 'Come' to the Brook," one large panel holds many smaller old frames, some highly ornate, some simple squares of wood, each framing Dickinson's manuscript poem (fig. 5). In some the poem is not quite contained by this boundary, but spills a few phrases or lines onto its frame. A closed folding chair and an ironing board also hang amidst this gallery of found objects in domestic counterpoint. On the floor, outside the panel, another identical folding chair stands open, as if inviting us to sit. This piece playfully incorporates the editorial questions raised by the reappraisal of Dickinson's manuscripts: What is art and what isn't? How does the way we present (frame) art change how we view it? Where does the frame of artistic appreciation end?

Like Barbara Penn's framings of text and Roni Horn's aluminum blocks of words, much of the art illustrated here builds Dickinson's words into physical things—taking literally the notion of a spatial language, or of poems as made objects. Paul Katz and Linda Schwalen make small artist's books out of Dickinson's poems as well as produce large canvases and drawings of her words on a page. Their styles are very different. Katz covers page or canvas with the words of a poem, running in one textual block, without line breaks or punctuation, over and over again until the surface is full (see pl. 12). The letters are hand-painted block capitals in a strong red against black, the texture of the oil paint made gritty with sand. The canvases, gradually diminishing in size, form a progression on the wall. By the final painting, the shadow of a tree has become discernible beneath the words. In

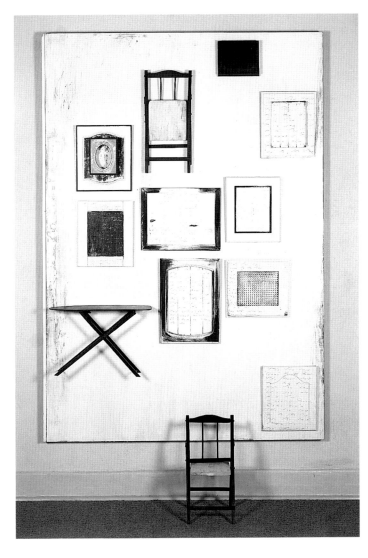

Figure 5

Barbara Penn

Poem No. 1210 "The Sea said 'Come' to the Brook," 1994

Mixed media installation

Collection of the artist

Schwalen's work, Dickinson's words are dismantled into single letters, and then, using a mixture of motor oil and graphite for ink, the letters are stenciled in horizontal and vertical patterns that weave through each other to produce a mesh of language that covers the top two-thirds of the white sheets (fig. 6). Some words remain legible in the jumble, *Caress* here, *long* there, but in no sense can these pages be read. For all their aesthetic differences, however, both artists insist that words and letters are visual units that do not transparently convey thought. Instead, in writing, sound and meaning are apprehended through the eye. Words become elements of design rather than carriers of textual signification. This recognition—that words are art—is one reason that Dickinson's poetry has become amenable as a source of inspiration for contemporary artists in a way that her anti-imagistic poems could not be in earlier decades.

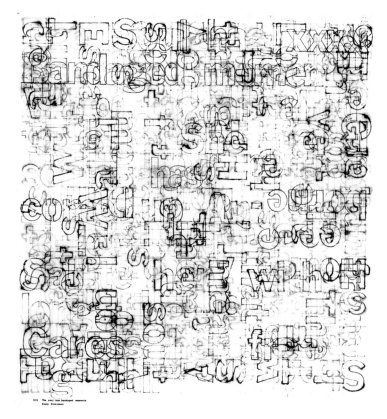

The most striking difference between Katz's and Schwalen's work is not the legibility of one and the illegibility of the other (Katz's densely full canvases are perfectly legible, but they don't really invite reading), but rather the connotations of their forms of lettering. Katz letters by hand; Schwalen uses more mechanical means. The phantom tree and rough surface of Katz's canvases, and the earth colors of his similarly structured artist's books evoke nature, whereas the tight weave of Schwalen's drawings conjure—at least for me—Massachusetts' textile mills. The difference is between seeing Dickinson as a natural poet,

inimicable to print and machine, or as a poet who, for all her legendary isolation remained engaged with a swiftly industrializing nation. In an essay on Roni Horn's sculptures, Ken Johnson complains of her Dickinson pieces that "although there was logic in the way poetic lines and stanzas were translated into blocks and bundles, the mechanical sculptural style was distractingly out of synch with the particularity of Dickinson's vision."[15] During her life Dickinson chose not to put her poems into print. Schwalen's mesh of printlike letters inked with motor oil and Horn's machined aluminum and plastic words disregard this choice. But they recognize that Dickinson's poetry does not simply withdraw from the era of print and industry any more than her life did. It was her father, after all, who saw to it that the railroad would run through Amherst.

There are costs to editors nonchalantly transposing her poems from manuscript to print, as if nothing were lost in the process. But there are also costs to nostalgically and sentimentally imagining Dickinson as fully separable from all mechanical taint.

The series of lithographs Robert Cumming named from the lines of a Dickinson poem have sculptural depth and industrial connotations (fig. 7 and see also pl. 7). The forms of these pieces echo three sculptures he produced for Boarding House Park in Lowell, Massachusetts. Their shapes derive from the nineteenth-century commercial spools and bobbins used by the young girls who worked in the mills and inhabited the boardinghouses of Lowell. The forms have strange, slightly ominous qualities, which they share with the poem recalled by their titles (*Smooth Mind, Eye Content, Upon the Head,* and *Knowing/Not Seeing*). This Dickinson poem divides like the ones sculpted by Horn into two stanzas, the first quite clear and direct, the second decidedly hermetic. Cumming draws all his titles from the second stanza.

The difference between Despair
And Fear—is like the One
Between the instant of a Wreck—
And when the Wreck has been—

The Mind is smooth—no Motion—
Contented as the Eye
Upon the Forehead of a Bust—
That knows—it cannot see—
(P 305)

Figure 7
Robert Cumming
Knowing/Not Seeing,
1989
Lithograph
Collection of the artist

Fear and despair may linger as emotions evoked by Cumming's lithographs. But in separating the smooth mind and content eye from this explanatory context, by producing these phrases as solid enigmatic objects, Cumming manifests the threat that likewise lurks in Dickinson's poem, the possibility of turning a person into a thing. Mill work notoriously manufactured such transformations. Yet Cumming's art celebrates industrialization as much as it critiques it. These are heroic, monumental objects, fascinating in their mystery, at once oddly familiar and unrecognizable. Cumming ends the introduction to a catalogue of his prints with another Dickinson poem about the mystical dimensions of scientific and industrial processes.[16]

Banish Air from Air—
Divide Light if you dare—
They'll meet
While Cubes in a Drop

Or Pellets of Shape
Fit
Films cannot annul
Odors return whole
Force Flame
And with a Blonde push
Over your impotence
Flits Steam.

<div align="right">(P 854)</div>

Cumming's late twentieth-century conceptions of technology make visible and meaningful Dickinson's own place as a poet who writes from the psychological and material crucible of an industrializing America—where the forces of mechanization cannot be annulled.

In his "Mind / Eye" series, Cumming suggests that consciousness can be hardened into a smooth, unresponsive, enigmatic thing. In these objects the emotional and personal are no longer discernible. Dickinson's concern with charting the spatial dimensions of thought and emotion professes a quite different relation between external, physical form and internal meaning. "The Outer—from the Inner / Derives its Magnitude" she explains in one poem, comparing the invisible power of interiority to the "unvarying Axis / That regulates the Wheel— / Though Spokes—spin—more conspicuous" (P 451). Dickinson insists on the superiority of the "Inner" soul, on its capacity to regulate and center physical experience. Her desire to dismiss the constraints of physical existence is not, however, without its problems, for what is an inner without an outer? The hub may center the wheel, but it is also formed by intersecting spokes; without spokes there would be no axis. Moreover, the pun on spokes needs to be taken seriously, for without such outward show there could be no speech and no poems, either. Dickinson's valorization of internal feelings and ideas that have no definite form constantly flounders on the unrecognizable and unspeakable nature of

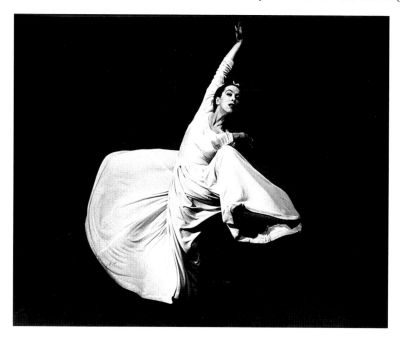

such internal states. Her poems must work as spokes to give solidity and shape to what is most mysterious, unsayable, and central about human experience; they strive to embody thought and feeling.

In *Letter to the World*, Martha Graham made dances of Dickinson's poems, letting the spectacular movements of her body speak them. Barbara Morgan returned this movement and flesh to still paper in her sequence of photographs of Graham dancing (fig. 8 and see pl. 13). "Since the dance is plastic and the photograph graphic there is a problem of translation," Morgan explains. "How

are these moments, whose medium is motion, to be expressed in the motionless photograph?"[17] This translation from poem to dance to photograph, from language to body to image, reveals the limits and possibilities of each medium, how differently each embodies thought. In describing her responses to Morgan's photographs, Martha Graham remarks how they "capture the instant of a dance and transform it into a timeless gesture."[18] Translating the "instant" into the "timeless" promises to combat mortality itself. In *Lyric Time*, Sharon Cameron shows how "Dickinson's lyrics are especially caught up in the oblique dialectic of time and mortality," most famously and provocatively in poems that claim to trespass the boundary that is death. Cameron explains that this capacity to blur temporal boundaries, to give the formless past and future a body in the present—extreme and explicit in Dickinson's poetry—remains structurally characteristic of the lyric as a genre. The succor that lyric time offers is a kind of "mythological present" that will not decay, but rather can bridge the abyss between past, present, and future, between life and death, motion and stasis.[19] Morgan's photographs achieve just such a crossing of temporal boundaries— making the body that moves through time, timelessly still, and making the still photograph move. Graham animates Dickinson's poems, dances Dickinson's words with her body (the production in fact included two Emilys, the paired roles of "One Who Speaks" and of "One Who Dances"), but the life-giving effects of such acts of embodiment also endow these poems with the body's capacity to die. "A dancer's instrument is his body bounded by birth and death. When he perishes his art perishes also," Graham writes, vainly attempting to mask her own mortality behind the anesthetized abstractions of the pronoun "he."[20] It is Morgan's photographs that have done most to keep the image of Graham's dancing body alive in cultural memory, but they have done so precisely through the arresting of motion, miraculously, uncannily holding the body in a position no actual body could sustain. Much changes in these translations from poem to dance to photograph, but through such shifts in medium it is that center, the human body, where time most grimly rests, and it is the goal of art to allay, if only for a moment, time's threat.

Lesley Dill has taken this complex relation of word, body, and photograph yet more literally in her photolithographs of a naked woman in which words from Dickinson's poems are written on the woman's flesh (fig. 9). Many of these prints take their titles

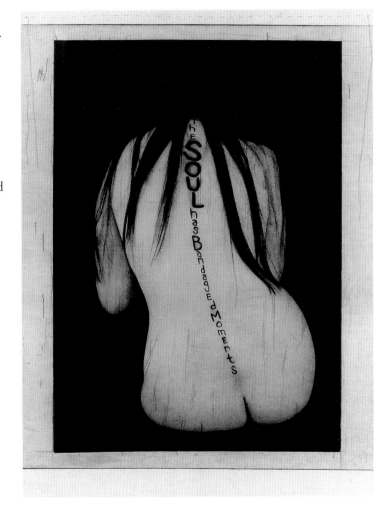

Figure 9

Lesley Dill
Word Made Flesh ("The SOUL has Bandaged Moments"), 1994

Photolithograph with etching on tea-stained Japanese mulberry paper, sewn with blue thread

Mead Art Museum

from different stanzas of a single Dickinson poem.

> The Soul has Bandaged moments—
> When too appalled to stir—
> She feels some ghastly Fright come up
> And stop to look at her—
>
> Salute her—with long fingers—
> Caress her freezing hair—
> Sip, Goblin, from the very lips
> The Lover—hovered—o'er
> Unworthy, that a thought so mean
> Accost a thing—so—fair—
>
> The soul has moments of Escape—
> When bursting all the doors—
> She dances like a Bomb, abroad,
> And swings upon the Hours,
>
> As do the Bee—delirious borne—
> Long Dungeoned from his Rose—
> Touch Liberty—then know no more,
> But Noon, and Paradise—
>
> The Soul's retaken moments—
> When, Felon led along,
> With shackles on the plumed feet,
> And staples, in the Song,
>
> The Horror welcomes her, again,
> These, are not brayed of Tongue—
> (P 512)

Dickinson's poem charts the movement between experiences of confinement and moments of liberation. The causes of both the horror and the delight evoked by this poem remain ambiguous and multiple, but certainly one important way of understanding this pattern is in terms of different experiences of the body, and especially of the sexual body. The body is, after all, what bandages the soul. Dill's prints—*The Soul has Bandaged Moments, The Soul has Moments of Escape,* and again *The Soul has Bandaged Moments*—work from the same photograph of a naked woman standing straight, with her arms down and feet together facing the camera. The poem is scrawled across her body, only occasional words really legible: "Ghastly" above the woman's breasts is large and clear; on her stomach "Cares" is all we can read of "Caress." The photographs that are the basis of each print are developed differently. In one print the image is so dark that the woman's head becomes invisible, her nipples and pubic hair appear as black holes; another is much lighter, the body more naturally contoured, the features of the face

delicately present; in yet another variant Dill employs the simultaneously domestic and brutal-sounding material of Butcher's Wax to create a very light image, a mere shadow of a woman, where only the dark spots of nipples and pubis are clearly marked. In all of these pieces the act of inscribing a woman's body suggests both the expressiveness and the vulnerability of flesh. If these bodies are made to speak, if these words are endowed with flesh, the process is not simply pleasurable and the result not simply an enhancement for woman or poem. Rather there is a strong recognition of pain and violence in these images. If the writing clothes this woman's nakedness, it also violates her flesh. Dill's work reminds us that embodiment entails gender, that the body bandaged and liberated in Dickinson's poem is female.

As an adult Emily Dickinson chose to clothe her body mostly in white dresses. This garb has become the most familiar and insistent image of Dickinson's virginal isolation. The stuff of legend, it is Dickinson's white dress that fashions her into "the New England Nun." Dill writes, "I think of words, especially poetry and especially Emily Dickinson's as a kind of spiritual armor. A protecting skin of words that dresses the soul with inspirations of vulnerability, fear and hope. As clothing cloaks or reveals, so does language, which can selectively present or obscure."[21] In her photolithographs, words seem more like wounds than like armor, but Dill's "Poem Dresses"—life-size sculptures of bronze or sewn-paper gowns cut with the letters of poems—stand strong as a fortress or prison (see pl. 1). A white dress features importantly in Morgan's photographs as well, but there the dress does not provide a rigid enforcement of chastity. Instead, the creases and folds of its cloth become the tangible, recordable signs of Graham's movements. These photographs are celebrated for the way they make motion visible, but the way Graham's dress is used to produce this effect has rarely been noted. It is the skirt that preserves the swirl of *Swirl* (fig. 8). If Graham were wearing only a leotard, Morgan's photograph would present her raised knee, her foot stepping forward, but there would be no way to trace where her leg had been. In contrast to the sexual repression the white dress symbolizes in Dickinson lore and evokes in Dill's metal sculptures, Morgan's photographs use the dress to trace process and to display the motion of Graham's fluid, sexual body. In his "Letter to a Young Contributor," Higginson writes blithely about "what a delicious and prolonged perplexity it is to cut and contrive a decent clothing of words . . . as a little girl does for her doll," but Dickinson rarely cares for what is "decent" and as Morgan's and Dill's work suggests, words clothe body and thought in complex and contradictory ways.[22]

Clothing and dolls are what girls are supposed to care about, especially wealthy Victorian girls. Dickinson's poetry—stark, demanding, luminous—consciously refuses such conventional preferences. Her work often draws on domestic and feminine imagery; this is, after all, the daily fabric of her experience. Yet her poetry resists domestication and ridicules the "Soft—Cherubic Creatures— / These Gentlewomen are—" with their "plush" decor and "Dimity Convictions" (P 401). Judy Chicago dresses Dickinson's place setting for *The Dinner Party* with lace: her Dickinson plate is made of porcelain lace and layers of lace and ribbon work also adorn the table runner (see pl. 5). Chicago explains, "I wanted to express this contrast between the poet's sense of herself and the Victorian concept of womanhood that would have strangled her autonomy. Despite the layers of porcelain lace and the lacy beribboned runner that surrounds the center of the plate, this core, though painted in pale colors, remains strong and un-

touched."[23] Like all the plates of powerful women assembled at Chicago's triangular dinner table, the "core" of Dickinson's plate is a vulva, the pale pink on the lace appearing to bleed from this redder center—suggesting the tension between the power of the female body and the confinement of female lives.

Carla Rae Johnson actually builds this dualism between feminine expectations and seething, powerful desires. On one side of her *Lectern for Emily Dickinson* climbs a chaste stair, all beige and white simplicity; on the other, a volcano glows with red lava (fig. 10 and see pl. 11).

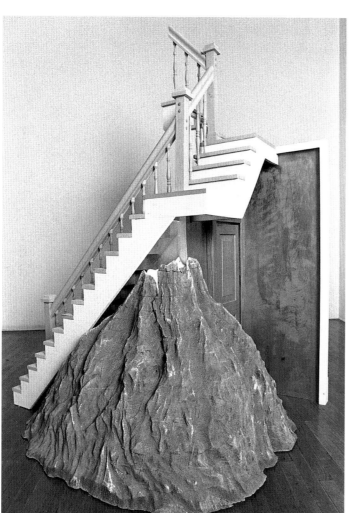

Volcanoes be in Sicily
And South America
I judge from my Geography—
Volcanoes nearer here
A Lava step at any time
Am I inclined to climb—
A Crater I may contemplate
Vesuvius at Home.

(P 1705)

The poem attests to Dickinson's capacity to find and express passion, anger, all the emotions domesticity strives to contain. For this she need not travel; she has, within herself, "Vesuvius at Home." The possibility of a newly expansive domesticity is also evoked by a number of Joseph Cornell's Dickinson boxes. It glimmers from the blue square of *"Toward the Blue Peninsula,"* and it emerges from the juxtaposition of Ecuadorian stamp and Chocolat Menier wrapper in a box Cornell assembled in 1959 (present location unknown). The wrapper of Menier baking chocolate becomes for Cornell a material referent to access Emily Dickinson.

Figure 10

Carla Rae Johnson

Lectern for Emily Dickinson (back view), 1994

Wood and mixed media

Collection of the artist

He had read in Millicent Todd Bingham's introduction to her 1945 anthology of Dickinson poems, *Bolts of Melody*, of how Dickinson wrote poems on stray bits of household paper: "many are written on the backs of brown paper bags, or on discarded bills, programs, and invitations. . . . There are pink scraps, blue and yellow scraps, one of them a wrapper of *Chocolat Meunier*; poems on the reverse of recipes in her own writing, on household shopping lists. . . ."[24] In this list, poetry uses and transforms the stuff of daily life. Dickinson baked all the bread and made most of the desserts for her household, the chocolate wrapper is thus a site of both domestic labor and artistic production. In Cornell's eight "Chocolat Menier" boxes (the spelling on the wrappers he found) this material object, which she used to compose her art and he to compose his, forms a link between them that traverses space and time (fig. 11). In itself it

suggests the possibility of remaking the domestic into something expansive. The 1959 Chocolat Menier box is a birdcage, but the hummingbird on the Ecuadorian stamp has traveled far. Dickinson wrote a poem that depicts the speed of a hummingbird as "The mail from Tunis," so swift as to be nearly invisible "A Route of Evanescence," "A Resonance of Emerald" (P 1463). Dickinson's Chocolat Meunier wrapper hailed from Paris.

Dickinson may have done much of the family baking, but in the well-to-do household of her father, a lawyer and politician, a household servant did most of the domestic labor. In *Embroidering Our Heritage*, Judy Chicago devotes eight pages to the needlework on the Emily Dickinson table-runner; three of them describe the horrendous working conditions of lace-makers. If lace "strangled" the wealthy women who wore it, lace killed and blinded the women who made it far more directly, through inadequate wages, long hours, poor light and ventilation.[25] Aífe Murray's pieces affirm the life and labors of three servants who worked for the Dickinson family during much of Emily's adult life: Margaret Maher, who served in the Dickinson household for thirty years, beginning in 1869; Thomas Kelley, who worked on the Dickinsons' properties; and his daughter, Margaret Kelley, who worked next door in the home of Emily's brother, Austin.[26] Murray shares an Irish ancestry with these servants and realized "it could have been my great grandmother churning Dickinson's butter." Her work makes visible how the domestic labor of Margaret Maher enabled Emily Dickinson to write. Thus she foregrounds the conditions that facilitate "the production of art as well as the art."[27] Murray paints queens on the cover of an ironing board, she paints a wooden chair in vivid colors, writing across it fragments from Margaret Maher's letters, and in her most ambitious piece in the "Pantry DRAWer" series she arranges a drawer-box with images of Maher and the Kelleys taken from an 1870 photograph (see pl. 14). The images are layered so that the faces of the two Margarets pasted against the back of the drawer appear half-covered by a second version of the portrait in which Murray has painted a rainbow halo around Margaret Maher's head. Of poetry and domestic labor Murray explains, "one work is visible, one invisible"; before she gets her halo, Maher is half-effaced.[28] The drawer is surrounded by odd but resonant objects: a shiny chain of green plastic shamrocks, a mop, a rosary, the cookbook *Better Meals for Less*, images of Mexican migrant laborers, and a painting of the Virgin framed by Mexican tin-work. The Catholic Mexican laborer provides

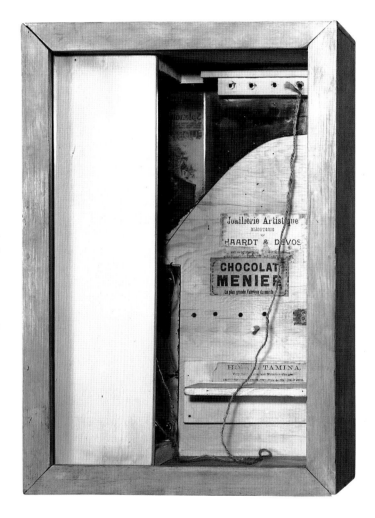

Figure 11

Joseph Cornell
Chocolat Menier, 1952
Mixed media
Grey Art Gallery and Study Center
New York University Art Collection

Murray with an apt contemporary analogue for the discrimination and exploitation experienced by Irish workers during the nineteenth century. By introducing these modern objects, Murray suggests how the limits placed on artistic production by class, religion, ethnicity, gender, and ever-accumulating household grime persist.

At stake in Murray's pieces is the question of cultural memory: Which labors strike us as deserving to be memorialized and which are we happy to discount, take for granted, or forget? *Language as Object: Emily Dickinson and Contemporary Art* asks the same questions about the cultural remaking and memorialization of Emily Dickinson. Traditionally, memorial sculptures attempt to monumentalize honor; a form of hagiography, they solidify questions and uncertainties into glory. But in this instance the questions linger, unsettling conventionally quaint, pietistic, and nostalgic understandings of Dickinson. This art models another way to read Dickinson precisely by taking her at her word, by recognizing the physical and spacial presence of her language. This art reminds us of how much the act of reading is an act of projection, even a feat of appropriation, of making a place for oneself within a poem—whether through Murray's Irish ancestry, or Penn's eggs and crib. Lesley Dill's sculpture *Poem Swallow* drops a string of copper letters from a pair of disembodied copper lips (fig. 12). Only the first few words of this Dickinson poem are legible before it tangles, unreadable, in a pile on the floor: "A Secret told—Ceases . . ." (P 381). The poem is about secrets, asserting how frightening they are to keep to oneself and yet how it may be more dangerous to share them. By titling her piece *Poem Swallow*, Dill asks us to see the string of secret words not only flowing from the mouth (a secretion), but also sucked in and consumed by it. This double motion of public presentation and internal consumption, at once material and subjective, characterizes the exhibition as a whole and what it means for these artists to memorialize Dickinson. As these pieces make her poems palpable they enable us—as viewers and as readers—to swallow, embody, and secrete her words.

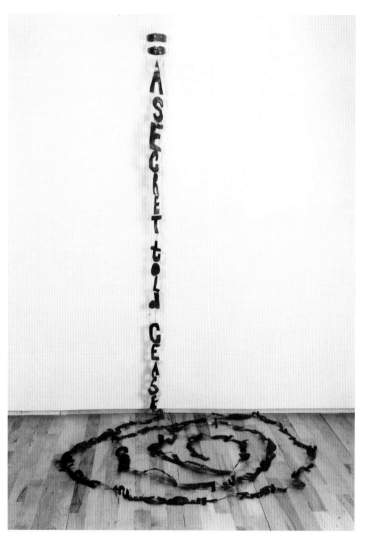

Figure 12
Lesley Dill
Poem Swallow, 1993
Copper and wire
George Adams
Gallery

NOTES

1 Emily Dickinson, letter of 25 April 1862 to Thomas Wentworth Higginson, *The Letters of Emily Dickinson*, 3 vols., ed. Thomas H. Johnson and Theodora Ward (Cambridge: Harvard University Press, 1958). Johnson numbered Dickinson's letters and poems for easy identification. This is L 261; all subsequent citations of Dickinson's letters refer to this edition and will be identified parenthetically within the text.

2 The title is a joke she shared with family friend Samuel Bowles, editor of the *Springfield Republican*. See Richard B. Sewall, *The Life of Emily Dickinson* (New York: Farrar, Straus and Giroux, 1974), 474.

3 David Porter discusses the connections between Cornell and Leyda in "Assembling a Poet and Her Poems: Convergent Limit—Works of Joseph Cornell and Emily Dickinson," *Word and Image* 10, no. 3 (1994): 205. For the literary criticism that inspired this artwork see Jay Leyda, *The Years and Hours of Emily Dickinson* 2 vols. (New Haven: Yale University Press, 1960), and Susan Howe, *The Birth-Mark: Unsettling the Wilderness in American Literary History* (Hanover, N.H.: University Press of New England, 1993), 139-40.

4 Susanna Rich, "Skin of Words: Leslie [*sic*] Dill's Poem Sculptures," *Emily Dickinson International Society Bulletin* 5, no. 2 (1993): 4.

5 I have used Johnson's variorum edition for the texts of Dickinson's poems, and, as with her letters, have employed his standard numbering to identify the poems I cite. This essay discusses some of the limitations of the Johnson edition, and I in no way mean to imply that these are the "best" or "truest" versions of her poems; they are in almost all cases, however, the version available to the artists on exhibit here. *The Poems of Emily Dickinson*, 3 vols., ed. Thomas H. Johnson (Cambridge: Harvard University Press, 1955).

6 Meg O'Rourke, "The Weight of the Word: The Sculpture of Roni Horn," *Arts Magazine* 66 (November 1991): 59.

7 Robert Weisbuch, *Emily Dickinson's Poetry* (Chicago: University of Chicago Press, 1975), 16.

8 Mary Frank in *Skies in Blossom: The Nature Poetry of Emily Dickinson*, ed. Jonathan Cott; illus. Mary Frank (New York: Doubleday, 1995), 97.

9 Jerome McGann discusses the obduracy of images in *Black Riders: The Visible Language of Modernism* (Princeton, N.J.: Princeton University Press, 1993), xiii-xiv.

10 *Poems by Emily Dickinson*, Third Series, edited by Mable Loomis Todd (Boston: Little Brown, 1896), 64.

11 Porter, "Assembling a Poet," 201.

12 Personal correspondence from Robert Lehrman, the owner of Joseph Cornell's *"Toward the Blue Peninsula,"* 7 February 1996.

13 Howe, *Birth-Mark*, 157.

14 Judith Farr, "Disclosing Pictures: Emily Dickinson's Quotations from the Paintings of Thomas Cole, Frederic Church, and Holman Hunt," *Emily Dickinson Journal* 2, no. 2 (1993): 76.

15 Ken Johnson, "Material Metaphors," *Art in America* 82 (February 1994): 71.

16 Robert Cumming, *Robert Cumming* (New York: Castelli Graphics, 1988).

17 Barbara Morgan, *Martha Graham: Sixteen Dances in Photographs* (1941; rev. ed., Dobbs Ferry, N.Y.: Morgan and Morgan, 1980), 150.

18 Graham made this comment in 1980 as a preface to the revised edition of Morgan's book of her dances. Morgan, *Martha Graham*, 8.

19 Sharon Cameron, *Lyric Time: Dickinson and the Limits of Genre* (Baltimore: Johns Hopkins University Press, 1979), 23, 134-35.

20 Morgan, *Martha Graham*, 11.

21 Lesley Dill, Artist Statement, May 1993. See the Dickinson exhibition file, Mead Art Museum.

22 Thomas Wentworth Higginson, "A Letter to a Young Contributor," *Atlantic Monthly* 9 (April 1862), reprinted in his *Atlantic Essays* (Boston, 1874), 76.

23 Judy Chicago, *Embroidering Our Heritage: The Dinner Party Needlework* (Garden City, N.Y.: Anchor Press, 1980), 235.

24 Millicent Todd Bingham, introduction to *Bolts of Melody: New Poems of Emily Dickinson*, ed. Mabel Loomis Todd and Millicent Todd Bingham (New York: Harper and Brothers, 1945), xii, xvi. Cornell's use of this passage from *Bolts of Melody* was first noted by Dore Ashton in *A Joseph Cornell Album* (New York: Viking Press, 1974), 40.

25 Chicago, *Embroidering*, 239-41.

26 Jay Leyda was the first scholar to note the importance of domestic servants, and particularly Maggie Maher, for Dickinson's life and poetry. See his "Miss Emily's Maggie," *New World Writing* 3 (1953): 255-67.

27 Aífe Murray, Artist Statement, "Rewoven Text / Lineage," June 1994. See the Dickinson exhibition file, Mead Art Museum.

28 Aífe Murray, *Margaret Maher, Emily Dickinson and Kitchen Table Poetics* (self-published mixed-media book, 1994) 1.

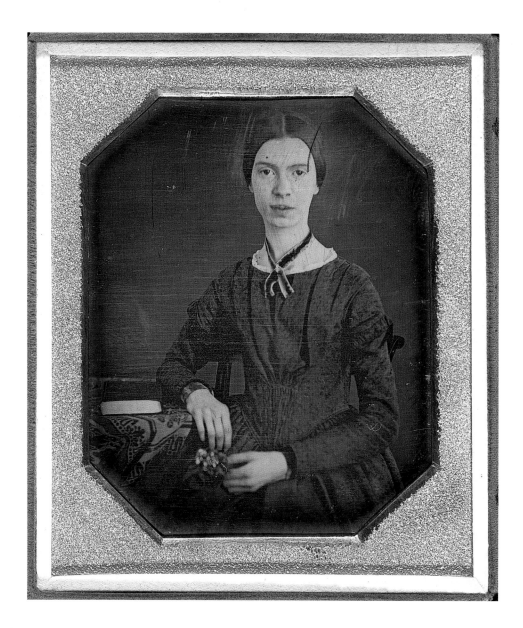

Plate 2

Attributed to Otis H. Cooley (act. 1844-55)

Emily Dickinson, ca. 1847

Daguerreotype

Amherst College Library

"Whose But Her Shy—Immortal Face"

The Poet's Visage in the Popular Imagination

Polly Longsworth

> *Were you ever daguerreotyped, O immortal man? And did you look with all vigor at the lens of the camera, or rather by direction of the operator, at the brass peg a little below it, to give the picture the full benefit of your expanded and flashing eye? and in your zeal not to blur the image, did you keep every finger in its place with such energy that your hands became clenched as for fight or despair, and in your resolution to keep your face still, did you feel every muscle becoming every moment more rigid; the brows contracted into a Tartarean frown, and the eyes fixed as they are fixed in a fit, in madness, or in death? And when, at last you are relieved of your dismal duties, did you find the curtain drawn perfectly, and the hands true, clenched for combat, and the shape of the face or head?—but, unhappily, the total expression escaped from the face and the portrait of a mask instead of a man? Could you not by grasping it very tight hold the stream of a river, or of a small brook, and prevent it from flowing?*

> RALPH WALDO EMERSON
> *Journal*, 24 October 1841

AFTER SITTING DIFFIDENTLY for her daguerreotype in 1847, Emily Dickinson found herself no more enchanted than Emerson was by the lifeless product of the camera, from which "the Quick" had fled (pl. 2).[1] She never again submitted to being photographed. The portrait made at age sixteen has become a tantalizing, powerful image of an only partially visible life, a picture that has played a role in shaping the iconography of and critical thinking about the poet.

Even those whose exposure to Dickinson is limited to a few most anthologized verses can recognize her face, the visage from the daguerreotype, with which book designers have waxed so ingenious (see fig. 18). Whether she is stylized or set in profile, whether adorned by wedding veil or spliced with Nefertiti, whether beautified or turned grotesque by small tamperings, Dickinson is popularly identifiable. Her face is as familiar as a mask and holds the mask's elusive promise that if we knew what she really looked like, underneath it, we would have the key to her enigmatic poetry.

Dickinson's earliest readers had no clue to her appearance, for the first two collections of her verse contained no picture of the shy, retiring author. These small dainty books, edited by Thomas Wentworth Higginson, a Boston man of letters who had been the poet's literary mentor, and Mabel Loomis Todd, an Amherst neighbor,[2] appeared in November 1890 and 1891 respectively, not long after the poet's death in 1886. While the poetry itself created a literary stir, the preface to each volume, one by Higginson

and one by Todd, together with two well-placed prepublication articles by Higginson, provoked enormous curiosity about the poet, an inquisitive interest the essays were designed to allay. Dickinson was presented as a remarkable recluse, a lonely, gifted woman buried in a country town, writing in secret, her profound poetic insights composed not for publication but for private sharing with friends and discovered only after her death. Readers were astonished. Who was this self-cloistered seraphic being who had dwelt invisible as a nun, shunning society and ignoring convention, who only emerged from seclusion once a year at the college commencement to help her father entertain distinguished guests?

Galvanized by her circumstances, which seemed as original as the poems themselves, reviewers devoted as much attention to Dickinson's oddities as to the discerning verses. Todd found herself speaking in public to defend the naturalness of Emily's retirement, to emphasize her joyous nature and define an apparent irreverence. Higginson's second prepublication article, appearing in the *Atlantic Monthly* of October 1891 just before release of the second volume, reproduced verbatim many of the poet's earliest letters and poems to him and described his two calls upon her, an act literarily akin to stripping the lid off her coffin, so gratuitously did it expose Dickinson's peculiar habits of mind and person along with her fine genius. Readers were enthralled, some drawn by the poet's exquisite sensitivity, others agreeing with the critic who found her "one of the strangest personalities of our time."[3]

In the absence of any visual image, Higginson provided his audience a verbal self-portrait by which to imagine Dickinson, quoting from the word picture she had supplied in July 1862 when he asked for her photographic carte-de-visite: "Could you believe me—without? I had no portrait, now, but am small, like the Wren, and my Hair is bold, like the Chestnut Bur—and my eyes, like the Sherry in the Glass, that the Guest leaves—Would this do just as well?" (L 268).

When the second volume of *Poems* created nearly the same popular sensation of the first, Todd, at Lavinia Dickinson's insistence, began readying Emily's letters for publication. In response to public avidity for stories about the unusual poet, several of Dickinson's relatives and friends leapt into print between 1891 and 1895 to defend or elaborate upon the Higginson-Todd narrative. Charming tales were told of Miss Emily among her flowers, of Miss Emily lowering a basket of goodies to children playing beneath her bedroom window. Secret tragedy and a blighted romance were hinted at. Weird habits of wearing snowy dresses, running from strangers, conversing from the shadows, having her envelopes addressed by amanuenses, and asking to be carried to the grave through the back door by family workmen were revealed. To satisfy speculation about Miss Dickinson's appearance, the publishers, Roberts Brothers of Boston, decided to include a picture of the poet in their edition of Todd's *Letters of Emily Dickinson*, which came out in November 1894.

What picture to use? There were only two: an oil portrait of the Dickinson children painted by artist O. A. Bullard during his itinerant days in 1840 (fig. 13), and a wobbly chinned silhouette cut by Emily's Amherst Academy tutor Charles Temple when she was fourteen (fig. 14). Then there surfaced the despised daguerreotype made when she was sixteen,[4] the one Dickinson herself had rejected, and which neither her sister, Lavinia (Vinnie), nor her brother, Austin, thought looked like her.

Long assumed lost, the sixth-plate likeness was brought forth by Margaret (Maggie) Maher, the Dickinson family's faithful maid, into whose possession it had drifted. According to a suppressed court deposition she made later, in 1898, Maggie also had harbored the poet's forty fascicles "in my trunk," whether at the Homestead or at her own home near the Amherst depot she didn't clarify.[5] Neither Maggie nor her trunk crept into the poet's narrative, for in a talk delivered in January 1895 Mabel Loomis Todd introduced the story that the poet's sister, "a few days after Emily's death, discovered a bureau drawer full of manuscript poems,"[6] a version of events that became a cherished element of Dickinson lore, along with the cherry bureau itself. According to Todd the bureau cache included "about 1200 poems, written on note paper, collected into bundles of 60 or 70 poems, and tied up with silk or thread; besides which there was a box of 'scraps,' with between 600 and 700 more poems and fragments." A very full drawer indeed.

To assist her publisher in securing a portrait of the poet pleasing to the Dickinson family, Todd oversaw the making of a photographic image from the newly found daguerreotype that consisted of head and bust alone against a pale background. The result, called a "cabinet photo" by Todd, was pronounced "dreadful." A composite sketch commissioned by publisher Thomas Niles was no more successful (fig. 15). Although in his drawing the artist neatly imposed wavy hair from a cousin's photograph upon the poet's photographic image, Austin and Vinnie felt he failed to catch their sister's expression.

The oil portrait of the nine-year-old Emily at least resembled her, decided Austin. Inadequate as it seemed, the child's face from the family portrait was isolated, given a set of shoulders, and placed as frontispiece to Volume 1 of the two-volume *Letters* (fig. 16). (Volume 2 featured a photograph of the stately Homestead, intended to counter inferences regarding Dickinson's rude, uncultured background.) For the next thirty years, then, a child's face anchored the outpouring of acclaim over this powerful, original, fresh New England voice. A child's face offset concurrent cries of imperfection and eccentricity, a ringing criticism over Dickinson's disregard for poetic conventions, her crudities of rhyme and grammar, the untutored structure of her singular verse.

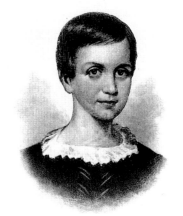

The Letters of Emily Dickinson was widely reviewed by middle-brow publications, but ignored by elite critics. It didn't sell beyond the first printing. A third volume of *Poems* in 1896, edited by Todd alone, also fared poorly. Emily Dickinson, it seemed, had had

her vogue. British reviewers dismissed her as provincial, "a kind of unfinished, rudimen-
tary (Emily) Brontë,"[7] and, as with that earlier poet, Dickinson seemed destined to
linger a half-developed child/woman in the public mind's eye. Further editing was
prevented by bitter animosity that erupted between the Todds and Dickinsons after the
death of Austin Dickinson in 1895. By century's end many hundred poems remained in
manuscript, but publication had halted with half the corpus of Dickinson's work still in
Todd hands and half held by Emily's heirs—Vinnie until her death in 1899, then
Austin's widow, Susan Dickinson and her daughter, Martha.

Vinnie didn't abandon the quest for a picture of Emily, however. In 1896,
three years before her death, she arranged for Boston miniaturist Laura C.
Hills to retouch a copy of the "cabinet photograph," the head and bust
taken from Emily's daguerreotype. After several stages, Hills pro-
duced a much softened, curly haired portrait with white dress and
clown-style ruffle that delighted Vinnie (fig. 17). She felt well
compensated for having impulsively given away Emily's disagree-
able daguerreotype to an Amherst College student, a distant
cousin, in 1893.[8] It didn't resurface until 1931.

The ruffled image of Dickinson was disclosed to the public in
1924 by the poet's niece, Martha Dickinson Bianchi, who inherited
it, along with all her aunt Emily's manuscripts except those in Todd
hands, when her mother died in 1912. Susan Dickinson had re-
spected Emily's proscription against publishing, but Bianchi, a pub-
lished poet herself and something of a romantic, at once began editing
her aunt's work and writing about her life. Between 1913 and 1937 she
produced six books of poetry and two of biography, some in collaboration with
her colleague Alfred Leete Hampson.[9] The touched-up Hills portrait appeared in nearly
all, beginning with *The Life and Letters of Emily Dickinson* (1924).

As Dickinson's canon emerged in piecemeal and rather bewildering fashion, and as
an echelon of highbrow critics that once had scorned her crudeness began to hail her as
a major modern voice, the general public seemed less enamored of the enigmatic verse
than of highly colored, sentimental portrayals of the poet herself. Readers assimilated,
along with the new white-ruffled image, Bianchi's intimate vision of a rare, mystic spirit
who wrote in "poetic flashes" on "gusts of impulse" and was hermetically protected by
her loving family against the world's intrusion. Evoking "the myth of Amherst," Bianchi
emphasized Emily's choice literary communion with "Sister Sue" and supplied gossipy
footnotes about her aunt's lifelong renunciation of love after "meeting her fate" in
Philadelphia. At least two other biographers proposed different candidates for
Dickinson's mysterious lover, one male, one female, around the centennial of her birth,
and George F. Whicher a professor at Amherst College, published one of the earliest
critical books about the poetry, despite having limited access to any organized poetic
canon.[10] But it was largely Bianchi's sharing of dozens of family letters and embellished
family anecdotes that created wide interest in the poet among an audience only
selectively interested in the poetry. At the same time, Bianchi's usurpation of the
contents of the earliest poetry volumes without acknowledgment quickly brought a
rival Emily to the fore.

Mabel Loomis Todd resented what she saw as Bianchi's misrepresentations. Errone-

Figure 17

Laura Combs Hills
(1859-1952)

Emily Dickinson

Photograph with
gouache

Emily Dickinson
Collection,
Houghton Library,
Harvard University
© The President and
Fellows of Harvard
College

ously convinced that she herself held legal rights to Dickinson's manuscripts, she published in 1931 an enlarged edition of her 1894 *Letters of Emily Dickinson* and used the opportunity to publicize the poet's daguerreotype. At first she had only the "cabinet photo" in her possession, but by the third printing the cousin to whom Vinnie had given the authentic portrait came forward, and the world finally met the stunningly direct gaze of a shy girl in dark cotton, her oiled hair severely smoothed and knotted, her throat encircled by a dark ribbon, her fingers plucking at a flower (see pl. 2). So powerful is the black-and-white statement that one rarely remembers Dickinson had auburn hair.[11]

In the wake of the realistic new image came the no-nonsense writings of Millicent Todd Bingham, Mabel Todd's daughter, who between 1945 and 1955 published four books based on Dickinson manuscripts and materials passed on to her by her mother.[12] One of them introduced more new poems, the other three focused with scholarly authority on the poet's life. By tracing Dickinson's background and upbringing with the aid of early family letters in her possession and by including the poet's "Master Letters" (three apparent love letters to an unknown recipient), as well as publishing evidence of a late love affair with Judge Otis P. Lord, Bingham added substantial complexity to what the public knew. With Harvard University's publication in 1955 of the three-volume variorum of Dickinson's poems and, in 1958, the three volumes of her complete letters, both edited by Thomas H. Johnson, Dickinson's literary debut was at last accomplished, nearly seventy-five years after her death.

Since then writing about Dickinson has become a major industry. Scores of books appearing in the past thirty-five years have advanced every conceivable theory about her art and her self. That her great body of poetry is able to sustain the numberless suppositions and personas projected upon it ("She may become the Victim, the Virgin, the Lesbian, the Frustrated Old Maid, the Lover, the Playful Puzzler, the Naturalist, the Eccentric, or the Psychotic," writes one essayist,[13] naming but some of the roles Dickinson has been made to play in recent years) reveals both its incredible strength and its utter abstractness. Her personality never fractures under this sometimes torturous process. It can be made to hold together whether she is represented as seer or secret wife, as agoraphobic or stand-up comedian, as religious pilgrim or psychotic, for by simultaneously encompassing human experience while extracting herself, Dickinson became in essence any and none of these. By straining to keep all traces of what she called "personality" out of her poems and letters, she made herself vulnerable to the imposition of multiple personalities. By practically swallowing herself in the effort to maintain a "polar privacy," she succeeded, paradoxically, in creating a vortex of compelling mystery which, with all the energy of a black hole, draws the public into a quest for her identity. Pilgrims to her bedchamber, actresses playing "The Belle of Amherst," artists and dancers interpreting her themes, writers sifting the endless clues to her life, and even candidates for Emily Dickinson look alike contests are all engaged in an act of finding.

Dickinson's inclusion in the ranks of international literary giants, her acceptance by intellectual peers as one of the foremost poets of the language, a bulwark of the Western canon, is the measure of her poetic achievement. But so is being recognizable on T-shirts, gracing a U.S. postage stamp, appearing familiarly in

Figure 18

The contemporary face of Emily Dickinson

national advertising and syndicated cartoons, and staring in endless variation from book jackets and gallery walls (fig. 18). While it is difficult to break away from Dickinson's iconic image, an artist who has been scientifically impelled is Nancy Burson, whose computer-generated portrait (fig. 19) advances Dickinson to age fifty-two by artificially "aging" the subject in the daguerreotype image. Burson's picture of a mature Dickinson, just before her final illness, makes us more appreciative of Lavinia Dickinson's crusade to "soften" the features of her sister's daguerreotype. But the enhancement also inspires, through a stiffening at our spine, awareness that we resist aging Emily. In addition to all other roles, we have conceived this poet as the female Peter Pan.

Figure 19

Nancy Burson (b. 1948)

Emily Dickinson at age 52, 1995

Computer-generated silver print

Mead Art Museum

True mysteries are fathomless. One of the tasks Millicent Todd Bingham set herself in her biographical study *Emily Dickinson's Home* was to determine where the daguerreotype of Emily Dickinson was made. Her researches turned up the fact that during the year Dickinson studied at Mount Holyoke Female Seminary an unnamed itinerant photographer visited South Hadley, in late December 1847 and early January 1848. Supposing that seventeen-year-old Emily, like many of the seminary students, sat for her portrait at that time, Bingham introduced the probability to Dickinson lore.[14] Fresh evidence of the 1990s, however, casts doubt on the interpretation, for nearly half a dozen scattered daguerreotypes have come to light (among them one of Emily's mother) that feature the distinctively patterned tablecover upon which Emily's arm rests. The cloth has been traced preliminarily, via the imprint on the mat of another portrait, to the studio of Otis H. Cooley, who operated as a daguerreotypist in Springfield, Massachusetts, from 1844 to 1855.[15] Possibly Emily, while visiting Norcross relatives in nearby Monson about 1847, went to Mr. Cooley's studio with her mother, with a result that disinclined her to further experiment at South Hadley. Possibly. With Dickinson the story is never finished.

How might we imagine Dickinson and her work if there were no photograph of her? Or, oppositely, if there were several photographs—of a smiling female, of a mature woman amidst friends and family, of a writer surrounded by the stuff of her trade? The lone daguerreotype of an adolescent Dickinson provokes more readings than either of these supposed conditions; at the same time, the single enigmatic image serves as a screen held up between this poet's unfathomable insecurities and our culture's incessant curiosity.

> A Charm invests a face
> Imperfectly beheld—
> The Lady dare not lift her Vail
> For fear it be dispelled—
>
> But peers beyond her mesh—
> And wishes—and denies—
> Lest Interview—annul a want
> That Image—satisfies—
>
> (P 421)

NOTES

[1] ED to Thomas Wentworth Higginson, July 1862. *The Letters of Emily Dickinson*, 3 vols., ed. Thomas H. Johnson and Theodora Ward (Cambridge: Harvard University Press, 1958), L. 268. Subsequent citations refer to this edition and will be placed in the text.

[2] In addition to having strong literary interests, Mabel Loomis Todd, wife of Amherst College astronomy professor David P. Todd, was intimate with members of the Dickinson family. She had exchanged notes and "attentions" with Emily while the latter was alive, was close to the poet's sister, Lavinia, and had a love affair with Austin Dickinson, the poet's brother.

[3] Critic M. A. deWolfe Howe, Jr., in "Literary Affairs in Boston" column, *Book Buyer*, September 1894, 378; quoted in *Emily Dickinson's Reception in the 1890s: A Documentary History*, ed. Willis J. Buckingham (Pittsburgh: University of Pittsburgh Press, 1989), 329.

[4] Although debate has ensued about the date of the daguerreotype, Lavinia Dickinson stated twice in the spring of 1893, in letters to Thomas Niles of Roberts Brothers, that Emily was sixteen when it was taken. (See Millicent Todd Bingham, *Ancestors' Brocades: The Literary Debut of Emily Dickinson* [New York and London: Harper and Brothers, 1945], 225, 226.) Because Dickinson's birthday fell on 10 December, she was sixteen during most of 1847.

[5] See the records of the Dickinson-Todd lawsuit of March 1898, in the files of the Supreme Judicial Court, Hampshire County Court House, Northampton, Mass. Instigated by Lavinia Dickinson against Mr. and Mrs. Todd, the suit ostensibly concerned ownership of a small strip of land, but back of the matter lay family jealousies involving proprietorship of Dickinson's poetry and the Mabel Todd-Austin Dickinson love affair.

[6] The talk, given in Worcester, Mass., was reported in the *Worcester Spy* next day (Buckingham, *Emily Dickinson's Reception*, 409).

[7] Buckingham, *Emily Dickinson's Reception*, 201.

[8] Millicent Todd Bingham, *Emily Dickinson's Home: Letters of Edward Dickinson and His Family* (New York: Harper and Brothers, 1955), appendix 1. Wallace Keep recalled Vinnie's giving him the daguerreotype in June 1892, but there is clear evidence in Mabel Loomis Todd's diary and in her letters to Thomas Niles that the portrait was in Vinnie's and Mabel's hands in the early spring of 1893. Therefore the date given here for Vinnie's impetuous generosity seems likelier.

[9] Martha Dickinson Bianchi's publications were *The Single Hound*, 1914; *The Life and Letters of Emily Dickinson*, 1924; *The Complete Poems of Emily Dickinson* (with A. L. Hampson), 1924; *Further Poems of Emily Dickinson*, 1929; *The Poems of Emily Dickinson*, Centennial Edition, 1930; *Emily Dickinson Face to Face: Unpublished Letters with Notes and Reminiscences*, 1932; *Unpublished Poems of Emily Dickinson* (with A. L. Hampson), 1935; and *Poems by Emily Dickinson* (with A. L. Hampson), 1937. The volumes of poetry were published by Little, Brown, and Company of Boston, and the two books of biography and memoir by the Houghton Mifflin Company of Boston and New York.

[10] George F. Whicher, *This Was a Poet: A Critical Biography of Emily Dickinson* (New York: Scribner's, 1938).

[11] "She wears a corset which has a long wooden busk inserted down the front to the point where her bodice fits. Hers is *not* a very tight, fashionable one, but still a young girl's easier fit, and the dress is not done in the smooth, snug fashion worn by smart, well-dressed women. That is due to her youth. The nice puff of her skirt comes from fine cartridge pleating and *several* petticoats. I think the dress is a good school-dress, made of a dark printed cotton. The neckline is a youthful one." Personal communique from Joan Severa, author of *Dressed for the Photographer: Ordinary Americans and Fashion, 1840-1900* (Kent, Ohio: Kent State University Press, 1995).

[12] Millicent Todd Bingham's books are *Bolts of Melody: New Poems of Emily Dickinson* (with Mabel Loomis Todd), 1945; *Ancestors' Brocades: The Literary Debut of Emily Dickinson*, 1945; *Emily Dickinson: A Revelation*, 1954; and *Emily Dickinson's Home: Letters of Edward Dickinson and His Family*, 1955. All were published by Harper and Brothers of New York.

[13] Karen Richardson Gee, "'My George Eliot' and My Emily Dickinson," *Emily Dickinson Journal* 3, no. 1 (1994): 25.

[14] See Bingham, *Emily Dickinson's Home*, 519.

[15] John Felix, "Otis H. Cooley: Possible Photographer of the Only Known Photograph of Emily Dickinson," *Journal of the Photographic Historical Society of New England*, nos. 3 and 4 (1995).

Plate 3
Emily Dickinson
*Fascicle Page — "Sea said 'Come'
to the Brook"*
Amherst College Library

Alcohol and Pearl

Dickinson's Imprint on American Poetry

Christopher Benfey

> I taste a liquor never brewed—
> From Tankards scooped in Pearl—
> Not all the Vats upon the Rhine
> Yield such an Alcohol!
>
> (P 214)

WHEN EMILY DICKINSON'S POEMS BEGAN APPEARING in thin volumes during the 1890s, one hundred years ago, there was considerable agreement that she was an avant-garde writer. Her innovations in subject and style were the occasion for either censure or celebration. Alice James, the brilliant sister of William and Henry James, noted with patriotic delight that British critics were deaf to Dickinson's peculiar, and peculiarly American, excellence. "It is reassuring to hear the English pronouncement that Emily Dickinson is fifth-rate," she reflected in January 1892, "they have such a capacity for missing quality; the robust evades them equally with the subtle."[1]

"'Alcohol' does not rhyme to 'pearl,'" sniffed one English reviewer, scowling at "I taste a liquor never brewed" (while implying that intoxicating experiment did not go well with aesthetic, "pearly" permanence).[2] But Dickinson's use of "slant" or approximate rhymes, of slang, of rhythms that pushed the limits of her metrical schemes—all these led some American reviewers to greet her posthumously published work as the very latest thing. And when anomalous or experimental poems by other poets were published, it was often to Dickinson that they were compared. The ironic, free-verse parables in Stephen Crane's *Black Riders*, perhaps the most original poetic production of the 1890s, displayed for one critic an "audacity of . . . conception, suggesting a mind not without kinship to Emily Dickinson's," while Dickinson's aging mentor and editor Thomas Wentworth Higginson, reviewing Crane's book anonymously in *The Nation*, discerned "an amplified Emily Dickinson," and thought Crane "grasps his thought as nakedly and simply" as she did. One reviewer even claimed a direct "influence," reporting that William Dean Howells had read aloud from Dickinson's poems in Crane's presence.[3]

But if Dickinson's poetry seemed resolutely avant-garde to many sophisticated, turn-of-the-century readers, it appealed to traditionalists as well, especially to those who felt she perfectly captured a certain lost New England world, an austere landscape of the spirit all but eliminated by Gilded Age excesses. Howells, in his handsome tribute in *Harper's*, claimed that in her work "America, or New England rather, had made a distinctive addition to the literature of the world," adding that "this poetry is as characteristic

of our life as our business enterprise, our political turmoil, our demagogism, our millionairism." He might have quoted Dickinson herself in this regard, who once described a "quality of loss," as though "Trade had suddenly encroached / Upon a Sacrament" (P 812).[4]

Likewise, Samuel Ward, Margaret Fuller's close friend and an early writer for the *Dial*, wrote to Higginson shortly after the publication of the first edition of Dickinson's *Poems*:

> I am, with all the world, intensely interested in Emily Dickinson. No wonder six editions have been sold, every copy, I should think to a New Englander. She may become world famous, or she may never get out of New England. She is the quintessence of that element we all have who are of the Puritan descent *pur sang*. We came to this country to think our own thoughts with nobody to hinder. . . . We conversed with our own souls till we lost the art of communicating with other people. The typical family grew up strangers to each other, as in this case. It was *awfully* high, but awfully lonesome.

Higginson called the letter "the most remarkable criticism yet made on E.D."[5]

Paradoxically, though, the strongest argument for Dickinson as the quintessential, "pure-blooded" upholder of New England traditions came not from New Englanders like Higginson and Ward, but from writers of the American South, who found in Dickinson's poetry a voice strangely kindred to their own. Dickinson received little attention from poets or critics during the first two decades of the new century. Then in 1924, the Savannah-born poet Conrad Aiken edited a selection of Dickinson poems for British readers, with a preface that is the first major essay on Dickinson's work. Calling her "the most perfect flower of New England Transcendentalism," Aiken—one of a long line of poet-critics to write about Dickinson—noticed in her work the "singular mixture of Puritan and free thinker."

Nothing in Aiken's fluent and mellifluous poetry reminds us of Dickinson's (in his words) "bare, bleak, and fragmentary" work, however. He complained that "her poetry seldom became 'lyrical,' seldom departed from the colorless sobriety of its bare iambics and toneless assonance." (We might complain that his poetry was, if anything, *too* "lyrical," too in love with its tuneful vowels.) But he relished her "freedom of utterance," the way "anything went by the board if it stood in the way of thought."[6]

One might expect Dickinson's originality and waywardness to have triumphed in the heroic 1920s of American writing, when, as Alfred Kazin remarked in a famous passage, "all the birds began to sing . . . [and] the emergence of our modern American literature after a period of dark ignorance and repressive Victorian gentility was regarded as the world's eighth wonder, a proof that America had at last 'come of age.'"[7] Too often, though, it was Whitman who seemed, to the poets and novelists of the 1920s, the lyrical liberator who, with his expansive lines and explosive social philosophy, had heroically slipped the yoke of European convention.

Even those poets who leaned toward a more cryptic phrasing and a smaller canvas looked less often to Dickinson than one might suppose. Part of the problem was a sense that her life—or at least what was known of it—did not sufficiently express that escape from "repressive Victorian gentility." Aiken, in a hooded aside, mentioned the "spinsterly angularity" of her writing, as though marriage would have somehow

"rounded" it.[8] And William Carlos Williams, whose lean, imagistic lines in *Spring and All* (1921) have some of the miniaturist clarity of Dickinson's verse, took aim at American women poets generally, and Dickinson in particular, in a difficult and disturbing passage in his own attack on Victorian gentility, *In the American Grain*:

> It is the women above all—there never have been women, save pioneer Katies; not one in flower save some moonflower Poe may have seen, or an unripe child. Poets? Where? They are the test. But a true woman in flower, never. Emily Dickinson, starving of passion in her father's garden, is the very nearest we have ever been—starving.
> Never a woman: never a poet. That's an axiom. Never a poet saw sun here.[9]

The phrase "woman in flower" hearkens back to Aiken's hint that virginity was somehow a hindrance to full poetic expression. But as the feminist poet-critic Sandra Gilbert has recently remarked, Williams did understand that imaginatively "Dickinson *was* starving in Victorian Massachusetts . . . and that she couldn't be—in the 'ordinary' sense—either a woman or a poet."[10]

Clearly, an unusually perceptive temperament was needed to find in Dickinson's work, during the 1920s, a heroism comparable to Whitman's noisier, self-celebrating "barbaric yawp." Hart Crane, who himself knew something about "starving of passion" in his father's garden, had such a temperament. Mulling over his own outsider status, as a homosexual amid masculinist poets like Williams and Ezra Pound, Crane had already, in his great poem "The Bridge," revealed a more vulnerable side of Whitman.

In 1927, a few years before his suicide, Crane began his sonnet "To Emily Dickinson" with that hunger Williams had sensed in Dickinson: "You who desired so much—in vain to ask— / Yet fed your hunger like an endless task, . . ." He saw her as a reconciler of opposites—"Some reconcilement of remotest mind"; and he answered the bloomless flower claim of Williams and Aiken with the line, "—Truly no flower yet withers in your hand, / The harvest you descried and understand / Needs more than wit to gather, love to bind." Crane also paid tribute, in the very un-Dickinsonian form of the sonnet, to Dickinson's genius in the use of abstractions and exotic diction ("Leaves Ormus rubyless, and Ophir chill").[11]

But the real trumpet blast that heralded Dickinson's arrival on the American literary map (or, to change metaphors, in the canon) came from Crane's friend Allen Tate, the reactionary Southern poet and brilliant critic, in an essay of 1932—when Tate could still complain that "Miss Dickinson's poetry has not been widely read." By then, enough of Dickinson's poems had appeared, especially after the *Complete Poems* of 1924, to make critics feel—erroneously, it turned out—reasonably confident that they had her oeuvre in hand.

Tate was a leading figure in the southern literary movement of the 1920s generally referred to as the Agrarians (for their attachment to allegedly rural values and their rejection of northern industrialism) or the Fugitives (for the literary magazine they founded in Nashville). The Fugitives attacked what they perceived as the money-grubbing tendencies of the United States (what Howells had called "our millionairism"), and looked to the best traditions of the Old South—especially religious traditions—for alternative modes of life. While lamenting that the South "had no . . . Emily Dickinson,"

Tate nonetheless turned Dickinson into a sort of honorary Southerner, "a deep mind writing from a deep culture," untouched by "the rising plutocracy of the East." (A somewhat misleading claim: if Dickinson's father and brother did not excel in the "plutocracy," it was not for lack of effort; in any case, the two treasurers of Amherst College did well enough in the world.)

In his extraordinarily influential essay on Dickinson, Tate managed to conflate the two competing conceptions—avant-garde poet versus traditional New England temperament, alcohol versus pearl—of Dickinson's work during the 1890s. He argued that Dickinson, "born into the equilibrium of an old and a new order," came of age at the ideal time for a poet—hers was "the perfect literary situation." She had the advantage of an orthodox and highly structured set of theological beliefs and intellectual traditions, namely those of Puritan New England, but this world was on the wane—"The spiritual community" was "breaking up"—and she could dwell in it without being imprisoned within it. Instead, it was available to her imagination: religious ideas and abstractions were "momently toppling from the rational plane to the level of perception."

At the same time, Tate cavalierly brushed away the "modern prejudice . . . that no virgin can know enough to write poetry," arguing that "all pity for Miss Dickinson's 'starved life' is misdirected. Her life was one of the richest and deepest ever lived on this continent."[12]

THE PUBLICATION OF DICKINSON'S COMPLETE POEMS IN 1955 and her collected letters three years later sparked extraordinary interest among American poets in Dickinson's work. Allen Tate's stress on Dickinson's religious vocabulary and traditional culture found persuasive expression in Richard Wilbur's elegant poem "Altitudes" (1956), with its comparison (or rather equation) of two perspectives, the dome of St. Peter's in Rome and Emily Dickinson's cupola in Amherst. In an important essay published the same year, which recapitulates much of Tate's argument, Wilbur chose Dickinson's phrase "Sumptuous Destitution" to name what he took to be the central strategy in her work— a sort of less-is-more attitude. This "paradox that privation is more plentiful than plenty" could—in Wilbur's view—make a Rome of Amherst.[13]

As early as 1896, Higginson had noticed how Dickinson often employed "two glances from different points of view" at the same idea.[14] Such a strategy is at work in Wilbur's "Altitudes" and—if we may jump forward in time for a moment—in Amy Clampitt's double perspective in "Amherst," which twins the view from Dickinson's Main Street address with that from the War Memorial at Amherst College. Clampitt and Wilbur share as well a decorous use of language; their finely tuned stanzas correspond to Dickinson's deft handling of inherited literary forms. Thus they enlist Dickinson, almost surreptitiously, as an upholder of New England traditions in the Higginson and Samuel Ward mode. (Of course, Wilbur's alignment of Amherst and Rome implies, by bestowing spiritual authority on Dickinson, another element of those traditions.)

As the examples of Wilbur and Clampitt show, what American poets have "gotten" from Dickinson has not always been predictable; her "imprint" on American poetry after 1955 cannot be traced in exclusively stylistic or technical instances. Several members of the group of American poets who came of age during the 1950s—among them the "confessional" poets John Berryman and Randall Jarrell—were intensely interested in

Dickinson. The Southerner Jarrell, who had studied with the Fugitive poets Tate and John Crowe Ransom in his youth, was taking notes for an extended essay on Dickinson at the time of his suicide in 1965.

In some of his own most effective later poems, Jarrell had been experimenting with women's voices, not so much in the older mode of the dramatic monologue—the creation of "believable" women characters—but in an uncanny attempt to probe his own androgynous self. Jarrell was thrilled to find confirmation (and provocation) for his experiments in Dickinson's practice. He reminded himself to "Notice change in versions" of poem 446 (from "I showed her Heights she never saw" to "He showed me Hights I never saw—"), and in the contrasting versions of "Going to Him! Happy letter!" / Going—to—Her! / Happy—Letter!" (P 494).[15]

Berryman too was proud of his skill in what he called "the administration of pronouns." Without playing with "ambiguous pronouns," he claimed, he could never have written his first major poem, *Homage to Mistress Bradstreet*. Berryman didn't much like the poetry of his "muse," the seventeenth-century American poet Anne Bradstreet; she concerned him, he admitted, "almost from the beginning, as a woman, not much as a poetess." His "impersonation" of her was an attempt to inhabit her body, and to experience imaginatively such female experiences as childbirth.[16]

But late in his life (like Jarrell), Berryman became obsessed with Dickinson. Having modeled the sprawling form of his *Dream Songs* on Whitman's *Song of Myself*, he tried in his last few books to learn all he could from Dickinson's leaner poetry. Judging from his late tribute to her, "Your Birthday in Wisconsin You Are 140," it was a certain wildness in the language and behavior of "Squire Dickinson's cracked daughter" that appealed to him most, as his own life unraveled in alcoholism and eventual suicide. Some biographical details are garbled in his poem—Dickinson deflected Judge Otis Lord's attentions, not the reverse—but it remains a handsome rebuttal to Higginson's early qualms about Dickinson's poems.

Higginson's response to Dickinson's "cracked" poetry (more alcohol than pearl, is his view) is also the starting point for Adrienne Rich's very different (and far more effective) poem of 1964. "'I Am in Danger—Sir'" is, among other things, a meditation on the peculiar fate of Dickinson's posthumous reception, which Rich sees as a sort of embattled museum of relics, scraps, objects that fail to cohere. Rich shares Berryman's sympathy for Dickinson's subversive "wildness" (in marked contrast to Wilbur's decorous version of her). And Rich, like Jarrell, is interested in Dickinson's subverting of gender: "you, woman, masculine / in single-mindedness." Rich's poem makes a fine pendant for her classic essay on Dickinson, "Vesuvius at Home" (1975), which develops some of the same ideas of the explosive imagination lurking behind the "feminine" decorum of Dickinson's daily life. Rich's excavation of Dickinson's life and work, and her focus on such theretofore neglected poems as "My Life had stood—a Loaded Gun" (P 754), set the agenda for the feminist criticism of Dickinson (such as Sandra Gilbert and Susan Gubar's pioneering *Madwoman in the Attic*) as well as feminist poetry about her (again, Sandra Gilbert's work, such as "Emily's Bread," comes to mind) that flourished during the 1980s.[17]

The "half-cracked," subversive Dickinson served as inspiration for a parallel movement in American poetry, also—like feminist writing—with its roots in the late 1960s. Such neosurrealist poets as James Tate, Charles Simic, and Charles Wright have all

expressed their indebtedness to Dickinson, and in particular to the waywardness and quick leaps of her imagination. Tate, in his "Thoughts While Reading *The Sand Reckoner*" (a late poem in his Pulitzer-prize winning *Selected Poems*),[18] stages a dreamlike encounter with his neighbor Emily Dickinson (he lives in Pelham, adjacent to Amherst, and teaches at the University of Massachusetts):

> "Tears are my angels now," she said to me
> around 4 A.M. "But are they interested
> in Cedar Rapids?" I asked. "I'm not qualified
> to say," was her sorry reply. And so it went,
> the sound of a crossbow humming. . . .

The Yugoslav-born Simic, author of a recent book on Joseph Cornell, has remarked that Dickinson's poems "think as they unfold—that's my dream! My hope is to understand her great art before I die."[19]

Allen Tate's idea that there was something "Southern" about Dickinson's imagination resurfaced a half century later, when the Tennessee-born poet Charles Wright (who once remarked that Dickinson was "the only writer I've ever read . . . whose work has influenced me at my heart's core") found a kinship between Dickinson's hymn meters and "the ballad and hymn measures that A. P. Carter [of the country music Carter Family] consistently wrote his gospel songs in." Wright also heard a parallel between Dickinson's "surreal simplicity and ache" and Carter's song lyrics, which were "traditional and oddly surreal at the same time."[20]

And today? Nothing is harder to map, in literary matters, than the present moment. But certain shared tendencies are apparent in recent poetry explicitly engaging Dickinson's work. There is, for example, a reluctance to approach Dickinson frontally, in the manner of Hart Crane or Berryman; recent poets seem to take to heart Dickinson's own injunction to tell it slant, since "Success in Circuit Lies." One notes a frank curiosity about the margins of Dickinson's life, and the mysteries that still surround those margins. Amy Clampitt, in her poignant "My Cousin Muriel," charts her own cousin's migration to the West Coast, where she lies dying,

> part of the long-drawn larger movement
> that lured the Reverend Charles Wadsworth
> to San Francisco, followed in imagination
> from the cupola of the shuttered homestead
> in Amherst where a childless recluse,
> on a spring evening a century ago, A.D.
> (so to speak) 1886, would cease to breathe
> the air of rural Protestant New England.[21]

Thomas Lux's poem about Dickinson's mother is unthinkable without Cynthia Griffin Wolff's biography (1986), which gives intense attention to the problematic mother bond in Dickinson's early childhood. Mary Jo Salter's "Reading Room" describes the present-day library at Mount Holyoke College (where Salter teaches) as a way to summon Dickinson's days at Mary Lyon's Mount Holyoke Female Seminary.

Two ambitious recent engagements with Dickinson's work are those of Lucie Brock-Broido and Agha Shahid Ali. Brock-Broido has meditated long and hard on the three famous and enigmatic letters found among Dickinson's possessions at her death. Known as the "master letters" for the addressee of two of them, we do not know the intended recipient, nor even whether Dickinson ever meant to mail them. What Brock-Broido has done in her extraordinary book *The Master Letters* (1995) is to feel her way imaginatively into the language and tone of these letters, and view her own experiences through their distorting lens. Sometimes adopting the very form and language of the letters, sometimes relying on a more oblique relation, the resulting poems are unsettling, elusive, and uncanny.

Agha Shahid Ali, born in Kashmir (a favorite place name for Dickinson, as Ali, who teaches at the University of Massachusetts at Amherst, notes), uses a somewhat analogous strategy, channeling his own experience through the conduit of one Dickinson poem, the hummingbird riddle she sent as a gift to (among others) Mabel Loomis Todd, who was her brother's lover and was to become her own posthumous editor. Ali evokes Dickinson's "route of evanescence" as a figure both for the fleeting passage of life and for his own roving geographical trajectory from Asia to America ("The mail from Tunis," as Dickinson wrote, "An easy Morning's Ride"). The occasion for Ali's poem "A Nostalgist's Map of America," and of the related sequence "In Search of Evanescence," is the death from AIDS of a friend—precisely the sort of subject Dickinson the elegist was drawn to.

Both Brock-Broido and Ali suggest a widening, even a globalizing, of Dickinson's imprint. The old tension between avant-garde and traditional, subversion and authority, alcohol and pearl, which emerged in the 1890s and defined the reception of Dickinson among American poets through most of the twentieth century, has yielded to a larger tension of local and global, as Dickinson's imprint continues to extend its reach.

NOTES

[1] Quoted in Jean Strouse, *Alice James: A Biography* (New York: Bantam, 1982), 320.

[2] Andrew Lang, writing anonymously, "The Newest Poet," *Daily News* [London], 2 January 1891, reprinted in *Emily Dickinson's Reception in the 1890s: A Documentary History*, ed. Willis J. Buckingham (Pittsburgh: University of Pittsburgh Press, 1989), 81.

[3] See Christopher Benfey, *The Double Life of Stephen Crane* (New York: Knopf, 1992), 131.

[4] William Dean Howells, "Editor's Study," *Harper's New Monthly Magazine* (January 1891). Quoted in Buckingham, *Emily Dickinson's Reception*, 78. The poems quoted are from *The Poems of Emily Dickinson*, 3 vols., ed. Thomas H. Johnson (Cambridge: Harvard University Press, 1955); poem numbers are given in parentheses.

[5] Both authors quoted in Richard B. Sewall, *The Life of Emily Dickinson* (New York: Farrar, Straus and Giroux, 1974), 26.

[6] Conrad Aiken, "Emily Dickinson," from *A Reviewer's ABC* (1935), reprinted in *Emily Dickinson: A Collection of Critical Essays*, ed. Richard B. Sewall (Englewood Cliffs, N.J.: Prentice-Hall, 1963), 12, 13, 15.

[7] Alfred Kazin, *On Native Grounds: An Interpretation of Modern American Prose Literature* (San Diego: Harcourt Brace, 1982), xiii.

[8] Aiken, "Emily Dickinson," 15.

[9] William Carlos Williams, *In the American Grain* (New York: New Directions, 1925), 179.

[10] Sandra M. Gilbert, "'If a lion could talk . . .': Dickinson Translated," *Emily Dickinson Journal* 2, no. 2 (1993): 5.

[11] Hart Crane, "To Emily Dickinson." See the selection of poems that follows. No further references to this selection will occur in these notes.

[12] Allen Tate, "Emily Dickinson," in *The Man of Letters in the Modern World: Selected Essays: 1928-1955* (Cleveland: Meridian, 1955), 211, 224, 221, 215-16. See also Tate's "The Profession of Letters in the South" (1935), same collection, for remarks about the South having "no Emily Dickinson," and on "the rising plutocracy of the East" (307).

[13] Richard Wilbur, "'Sumptuous Destitution,'" in *Responses: Prose Pieces, 1953-1976* (New York: Harcourt Brace Jovanovich, 1976), 3-15.

[14] From Higginson's review of Stephen Crane's poetry, quoted in Benfey, *Double Life*, 131.

[15] Quoted in Benfey, "The Woman in the Mirror: John Berryman and Randall Jarrell," in *Recovering Berryman: Essays on a Poet*, ed. Richard J. Kelly and Alan K. Lathrop (Ann Arbor: University of Michigan Press, 1993), 158. I would again like to thank Mary Jarrell for showing me Jarrell's marginalia in his volumes of Dickinson's poetry.

[16] See Benfey, "The Woman in the Mirror," 160-63.

[17] Adrienne Rich, "Vesuvius at Home: The Power of Emily Dickinson," *On Lies, Secrets, and Silences: Selected Prose, 1966-1978* (New York: W. W. Norton and Co., 1979), 157-83; Sandra M. Gilbert and Susan Gubar, *The Madwoman in the Attic: The Woman Writer and the Nineteenth-Century Literary Imagination* (New Haven: Yale University Press, 1979), 581-650.

[18] James Tate, "Thoughts While Reading *The Sand Reckoner*," in *Selected Poems* (Hanover, N.H.: Wesleyan University Press / University Press of New England, 1991).

[19] Simic quoted in Alice Fulton, "Her Moment of Brocade: The Reconstruction of Emily Dickinson," *Parnassus* 15, no. 1 (1989): 17.

[20] Charles Wright, "A.P. and E.D.," in *Halflife: Improvisations and Interviews, 1977-87* (Ann Arbor: University of Michigan Press, 1988), 53-55. See also Wright's poem "Visiting Emily Dickinson," in *The World of Ten Thousand Things: Poems 1980-1990* (New York: Farrar, Straus and Giroux, 1990), 161-62.

[21] Amy Clampitt, "My Cousin Muriel," in *Westward* (New York: Knopf, 1990), 65-68.

POETRY
PORTFOLIO

TO EMILY DICKINSON

You who desired so much—in vain to ask—
Yet fed your hunger like an endless task,
Dared dignify the labor, bless the quest—
Achieved that stillness ultimately best,

Being, of all, least sought for: Emily, hear!
O sweet, dead Silencer, most suddenly clear
When singing that Eternity possessed
And plundered momently in every breast;

—Truly no flower yet withers in your hand,
The harvest you descried and understand
Needs more than wit to gather, love to bind.
Some reconcilement of remotest mind—

Leaves Ormus rubyless, and Ophir chill.
Else tears heap all within one clay-cold hill.

HART CRANE

ALTITUDES

I

 Look up into the dome:
It is a great salon, a brilliant place,
 Yet not too splendid for the race
Whom we imagine there, wholly at home

 With the gold-rosetted white
Wainscot, the oval windows, and the fault-
 Less figures of the painted vault.
Strolling, conversing in that precious light,

 They chat no doubt of love,
The pleasant burden of their courtesy
 Borne down at times to you and me
Where, in this dark, we stand and gaze above.

 For all they cannot share,
All that the world cannot in fact afford,
 Their lofty premises are floored
With the massed voices of continual prayer.

II

 How far it is from here
To Emily Dickinson's father's house in America;
 Think of her climbing a spiral stair
Up to the little cupola with its clear

 Small panes, its room for one.
Like the dark house below, so full of eyes
 In mirrors and of shut-in flies,
This chamber furnished only with the sun

 Is she and she alone,
A mood to which she rises, in which she sees
 Bird-choristers in all the trees
And a wild shining of the pure unknown

 On Amherst. This is caught
In the dormers of a neighbor, who, no doubt,
 Will before long be coming out
To pace about his garden, lost in thought.

RICHARD WILBUR

YOUR BIRTHDAY IN WISCONSIN YOU ARE 140

'One of the wits of the school' your chum would say—
Hot diggity!— What the *hell* went wrong for you,
Miss Emily,—besides the 'pure & terrible' Congressman
your paralyzing papa,—and Mr. Humphrey's dying
 & Benjamin's (the other reader)? . .

Fantastic at 32 outpour, uproar, 'terror
since September, I could tell to none'
after your 'Master' moved his family West
and timidly to Mr. Higginson:
 'say if my verse is alive.'

Now you wore only white, now you did not appear,
till frantic 50 when you hurled your heart
down before Otis, who would none of it
thro' five years for 'Squire Dickinson's cracked daughter'
 awful by months, by hours. .

Well. Thursday afternoon, I'm in W——
drinking your ditties, and (dear) *they* are *alive*,—
more so than (bless her) Mrs F who teaches
farmers' red daughters & their beaux *my* ditties
 and yours & yours & yours!
 Hot diggity!

JOHN BERRYMAN

"I AM IN DANGER—SIR—"

"Half-cracked" to Higginson, living,
afterward famous in garbled versions,
your hoard of dazzling scraps a battlefield,
now your old snood

mothballed at Harvard
and you in your variorum monument
equivocal to the end—
who are you?

Gardening the day-lily,
wiping the wine-glass stems,
your thought pulsed on behind
a forehead battered paper-thin,

you, woman, masculine
in single-mindedness,
for whom the word was more
than a symptom—

a condition of being.
Till the air buzzing with spoiled language
sang in your ears
of Perjury

and in your half-cracked way you chose
silence for entertainment,
chose to have it out at last
on your own premises.

1964
ADRIENNE RICH

AMHERST

May 15, 1987

The oriole, a charred and singing coal,
still burns aloud among the monuments,
its bugle call to singularity the same
unheard (she wrote) as to the crowd,
this graveyard gathering, the audience
 she never had.

Fame has its own dynamic, its smolderings
and ignitions, its necessary distance:
Colonel Higginson, who'd braved the cannon,
admitted his relief not to live near such
breathless, hushed excess (you cannot
 fold a flood,

she wrote, and put it in a drawer), such
stoppered prodigies, compressions and
devastations within the atom—*all this
world contains: his face*—the civil
wars of just one stanza. A universe
 might still applaud,

the red at bases of the trees (she wrote)
like mighty footlights burn, God still
look on, his badge a raised hyperbole—
inspector general of all that carnage,
those gulfs, those fleets and crews
 of solid blood:

the battle fought between the soul and No
One There, no one at all, where cities
ooze away: unbroken prairies of air
without a settlement. On Main Street
the hemlock hedge grows up untrimmed,
 the light that poured

in once like judgment (whether it was noon
at night, or only heaven at noon, she wrote,
she could not tell) cut off, the wistful,
the merely curious, in her hanging dress discern
an ikon; her ambiguities are made a shrine,
 then violated;

we've drunk champagne above her grave, declaimed
the lines of one who dared not live aloud.
I thought of writing her (Dear Emily, though,
seems too intrusive, Dear Miss Dickinson too prim)
to ask, not without irony, what, wherever she
 is now, is made

of all the racket, whether she's of two minds
still; and tell her how on one cleared hillside,
an ample peace that looks toward Norwottuck's
unaltered purple has been shaken since
by bloodshed on Iwo Jima, in Leyte Gulf
 and Belleau Wood.

AMY CLAMPITT

EMILY'S BREAD

1857 *Emily's bread won a prize at the annual Cattle Show.*
1858 *Emily served as a judge in the Bread Division of the Cattle Show.*
—John Malcolm Brinnin, "Chronology," *Selected Poems of Emily Dickinson*

Inside the prize-winning blue-ribbon loaf of bread,
there is Emily, dressed in white,
veiled in unspeakable words,
not yet writing letters to the world.

No, now she is the bride of yeast,
the wife of the dark of the oven,
the alchemist of flour, poetess of butter,
stirring like a new metaphor in every bubble

as the loaf begins to grow.
Prosaic magic, how it swells,
like life, expanding, browning
at the edges, hardening.

Emily picks up her pen, begins to scribble.
Who'll ever know? "This is my letter
to the world, that never. . . ."
Lavinia cracks an egg, polishes

the rising walls with light. Across
the hall the judges are making notes:
firmness, texture, size, flavor.
Emily scribbles, smiles. She knows it is

the white aroma of her baking skin
that makes the bread taste good.
Outside in the cattle pen the blue-ribbon heifers
bellow and squeal. Bread means nothing to them.

They want to lie in the egg-yellow sun.
They are tired of dry grain, tired of grooming and love.
They long to eat the green old meadow
where they used to live.

SANDRA M. GILBERT

EMILY'S MOM

(Emily Norcross Dickinson, 1804-1882,
mother of Emily Elizabeth Dickinson, 1830-1886)

Today we'd say she was depressed, clinically. Then,
they called it "nameless disabling apathy," "persistent nameless
infirmity," "often she fell sick
with nameless illnesses and wept
with quiet resignation." *The Nameless*, they should
have called it! She was *depressed*,
unhappy, and who can blame her
given her husband, Edward, who was, without exception,
absent—literally and otherwise—and in comparison
to a glacial range, cooler by a few degrees.
Febrile, passionate: not Edward.
"From the first she was desolately lonely."
A son gets born, a daughter (the poet), another daughter,
and that's all, then nearly fifty years
of "tearful withdrawal and obscure maladies."
She was depressed, for christsake! The Black Dog
got her, the Cemetery Sledge, the Airless Vault,
it ate her up
and her options few: no Prozac then, no Elavil,
couldn't eat *all* the rum cake,
divorce the sluggard?
Her children? Certainly they
brought her some joy?: "I always ran home to Awe
when a child, if anything befell me. He was an Awful Mother,
but I liked him better than none."
This is what her daughter, the poet, said.
No, it had her,
for a good part of a century
it had her by the neck: the Gray Python,
the Vortex Vacuum.
During the last long (seven) years,
crippled further by a stroke,
it did not let go but, *but*: "We were never intimate
Mother and children while she was our Mother
but mines in the ground meet by tunneling
and when she became our Child, the Affection came."
This is what Emily, her daughter, wrote
in that manner wholly hers,
the final word
on Emily, her mother—melancholic,
fearful, starved-of-love.

THOMAS LUX

READING ROOM

Williston Memorial Library,
Mount Holyoke College

The chapter ends. And when I look up
from a sunken pose in an easy chair
(half, or more than half, asleep?)
the height and heft of the room come back;
darkly, the pitched ceiling falls
forward like a book.
Even those mock-Tudor stripes
have come to seem like unread lines.
Oh, what I haven't read!

—and how the room, importunate
as a church, leans as if reading *me*:
the three high windows in the shape
of a bishop's cap, and twenty girls
jutting from the walls like gargoyles
or (more kindly) guardian angels
that peer over the shoulder, straight
into the heart. Wooden girls who exist
only above the waist—

whose wings fuse thickly into poles
behind them—they hold against their breasts,
alternately, books or scrolls
turned outward, as if they mean to ask:
Have you done your Rhetoric today?
Your passage of Scripture? Your Natural
Philosophy? In their arch, archaic
silence, one can't help but hear a
mandate from another era,

and all too easy to discount
for sounding quaint. Poor
Emily Dickinson, when she was here,
had to report on the progress of
her soul toward Christ. (She said: *No hope.*)
Just as well no one demands
to know *that* any more . . . Yet
one attends, as to a lecture,
to this stern-faced architecture—

Duty is Truth, Truth Duty—as one
doesn't to the whitewashed, low
ceilings of our own. Despite
the air these angels have of being
knowing (which mainly comes by virtue
of there being less to know back then),
there's modesty in how they flank
the room like twenty figureheads;
they won't, or can't, reveal who leads

the ship you need to board. Beneath
lamps dangled from the angels' hands—
stars to steer us who knows where—
thousands of periodicals
unfurl their thin, long-winded sails;
back there, in the unlovely stacks,
the books sleep cramped as sailors.
So little time to learn what's worth
our time! No one to climb that stair

and stop there, on the balcony
walled like a pulpit or a king's
outlook in a fairy tale,
to set three tasks, to pledge rewards.
Even the angels, after all,
whose burning lamps invoke a quest
further into the future, drive
us back to assimilate the past
before we lose the words.

No, nobody in the pulpit
but for the built-in, oaken face
of a timepiece that—I check my watch—
still works. As roundly useful as
the four-armed ceiling fans that keep
even the air in circulation,
it plays by turns with hope and doubt;
hard not to read here, in the clock's
crossed hands, the paradox

of Time that is forever running out.

MARY JO SALTER

INTO THOSE GREAT COUNTRIES OF THE BLUE
SKY OF WHICH WE DON'T KNOW ANYTHING

16 March

Master—

Today has been a fair day, very still & blue. Tonight the snow will hunch on branches, shifting slightly like chicks hatched in a metal drawer bunched in rows, on the way to slaughter, incubating. The oak trees— ruined bare—tower in the sky like stick figures, graceless in wind, as schizophrenic children draw themselves as sticks, plugged in. *How I long to see you there at twilight in the door,* your old oak chair pulled up by the window, counting the white hours until Spring.

Sometimes I think I will be broken by your lukewarm Hand. Sometimes the triremes of the redundant Rush row over me, a Sabbath day of ritual, a few sweet hours, groomed as the fields combed over in aisles of alfalfa wheats, burnt down by Winter, ragged as Crows. If I could have your Hands on me, I would wish them on my face, cupped in the head's heart shape, unpunishing.

Then, at morning, the dowager who dwells in the Round House across the road—a sea captain's widowed wife—will pass on like a wren in dust—bearing her into those blue countries of the great sky of which we don't know anything. Not knowing the Sexton's address at sea, on land I will interrogate the bramble of her yard. She has only a sister, no god. Last Fall, when she buried her garden, I watched the hump of Winter cower in the garden path, crouching at the Circumference of her house like bands of Prayers in their pews around an altar lit by blue steam rising up.

What it must be like there in the pitch of Time; in Heaven an hour is for Always, like an ancient Viking tribe in Vessels, rowing home. I will be gliding in the slender dirty canals of the Ephemeral, disheveled as a woman face down in her bed, praying hard for Heat. *Does God take care of those at sea?*

The evenings grow colder now. I miss the gentians' greed, the Hand that tends the gentians' greed. Before the fields go coarse again in Spring, before the fields break open for a wide blue afternoon. When you wake crouching in your small Venetian boat, I will be long sliding toward Oblivion—*you tire me—*

Till Angels fill the Hand that Loaded—
Mine

LUCIE BROCK-BROIDO

A NOSTALGIST'S MAP OF AMERICA

The trees were soon hushed in the resonance
of darkest emerald as we rushed by
on 322, that route which took us from
the dead center of Pennsylvania.

(a stone marks it) to a suburb ten miles
from Philadelphia. "A hummingbird,"
I said, after a sharp turn, then pointed
to the wheel, still revolving in your hand.

I gave Emily Dickinson to you then,
line after line, complete from heart. The signs
on Schuylkill Expressway fell neat behind us.
I went further: "Let's pretend your city

is Evanescence—There has to be one—
in Pennsylvania—And that some day—
the Bird will carry—my letters—to you—
from Tunis—or Casablanca—the mail

an easy night's ride—from North Africa."
I'm making this up, I know, but since you
were there, none of it's a lie. How did I
go on? "Wings will rush by when the exit

to Evanescence is barely a mile?"
The sky was dark teal, the moon was rising.
"It always rains on this route," I went on,
"which takes you back, back to Evanescence,

your boyhood town." You said *this* was summer,
this final end of school, this coming home
to Philadelphia, WMMR.
as soon as you could catch it. What song first

came on? It must have been a disco hit,
one whose singer no one recalls. It's six,
perhaps seven years since then, since you last
wrote. And yesterday when you phoned, I said,

"I knew you'd call," even before you could
say who you were. "I am in Irvine now
with my lover, just an hour from Tucson,
and the flights are cheap." "Then we'll meet often."

For a moment you were silent, and then,
"Shahid, I'm dying." I kept speaking to you
after I hung up, my voice the quickest
mail, a cracked disc with many endings,

each false: One: "I live in Evanescence
(I had to build it, for America
was without one). All is safe here with me.
Come to my street, disguised in the climate

of Southern California. Surprise
me when I open the door. Unload skies
of rain from your distance-drenched arms." Or this:
"Here in Evanescence (which I found—though

not in Pennsylvania—after I last
wrote), the eavesdropping willows write brief notes
on grass, then hide them in shadows of trunks.
I'd love to see you. Come as you are." And

this, the least false: "You said each month you need
new blood. Please forgive me, Phil, but I thought
of your pain as a formal feeling, one
useful for the letting go, your transfusions

mere wings to me, the push of numerous
hummingbirds, souvenirs of Evanescence
seen disappearing down a route of veins
in an electric rush of cochineal."

for Philip Paul Orlando

AGHA SHAHID ALI

ART
PORTFOLIO

Emily Dickinson's Impact on Contemporary Art

Entries by Susan Danly with David Porter

S INCE THE 1940s when American artists first turned to Emily Dickinson as a source of inspiration, they have responded to both her life and her poetry in surprisingly diverse ways. The surrealist boxes of Joseph Cornell and the figural paintings of Will Barnet, for example, focus attention on the reclusive personality of the poet. The cerebral, conceptual works of Roni Horn and Robert Cumming draw on Dickinson's idiosyncratic use of language. And outspoken feminist artists, such as Judy Chicago and Aífe Murray, explore the particular social circumstances of a woman writer who simultaneously celebrated domestic and intellectual life. Many of the artists who deal with Dickinson's writing are also aware of current critical writing about the poet. In large-scale installation pieces by Barbara Penn and in smaller drawings by Linda Schwalen, the visual appearance of Dickinson's text, inscribed by the poet's hand or represented by more mechanical forms of writing, relates to issues first raised by contemporary literary critics.

In every instance, the artists chosen here have transformed Dickinson's original text—they have turned her written language into visual objects. Although these works of art are based on specific texts, they are not straightforward illustrations of Dickinson's literary images. Rather, they convey more generalized feelings of ambiguity, contradiction, and a heightened sense of visceral perception—the same characteristics that define Dickinson's peculiar mode of poetic expression.

Each of the following catalogue entries pairs the work of art with the Dickinson text which inspired its making. Most of the art works themselves, however, do not literally reproduce Dickinson's words; and when they do, the text is often difficult to read or even illegible. To understand and appreciate them fully requires the active participation of a knowledgeable reader and the open mind of a perceptive viewer.

Will Barnet

(b. 1911)

Plate 4

The Glass, 1990-91
["Between the form of
Life and Life," Poem
No. 1101]
Oil on canvas
21 1/2 x 23 1/2 in.
Collection of the
artist

IN A RECENT SERIES OF PAINTINGS based on Emily Dickinson's poems, Will Barnet has conflated his well-known "Woman by the Sea" image with the facial features and persona of the poet.[1] While the individual compositions of these paintings are based on specific poems, the contemplative woman in each resembles Barnet's portrait of Dickinson produced for an illustrated edition of her poems published in 1989.[2] Her oblique portrait is derived from the daguerreotype (see pl. 2), in which Dickinson confronts the viewer straight on, as does the woman who examines her reflection in *The Glass* (pl. 4). Barnet's painting also alludes to a description of herself that Dickinson supplied in a letter to her mentor, Thomas Wentworth Higginson: "I had no portrait, now, but am small, like the Wren, and my Hair is bold, like the Chesnut Bur—and my eyes, like the Sherry in the Glass, that the Guest leaves—" (L 268). Dickinson's hair was red, not black as in Barnet's painting, but she did wear it pulled back tightly in a bun as do the figures in his Dickinson series.

The painter's interest in the poet stems from his New England roots. He grew up in Beverly, Massachusetts, and as a young man taught art classes in Salem at the House of the Seven Gables, then a settlement house long associated with another important nineteenth-century literary figure, Nathaniel Hawthorne. Barnet's two unmarried sisters remained in the family home their entire lives in a domestic situation which the artist has compared to that of the Dickinson family household. The sparseness and general-ized detail of his realist style also seem well matched to Dickinson's poetry. His lone female figures, isolated in interior spaces or seen from outside framed against a window, convey an introspective, intellectual mood—the life of the mind rather than of the world.[3] They are depicted in an abstracted style of realist painting that represents the anticipatory, ecstatic "form of Life" that Dickinson preferred over the details of ordinary existence.

[1] Since 1990, Barnet has completed several paintings related to specific Dickinson poems (P 110, 130, 347, 351, 1138, and 1275), as well as figural works that include images of nature from her poems, such as moths, spiders, blackbirds, and owls. For a discussion, see Maryanne Garbowsky, "Will Barnet Meets Emily Dickinson," in *Emily Dickinson International Society Bulletin* 6 (Nov.-Dec. 1994): 8-9, 18. For a further discussion of the "Woman by the Sea" series see Robert Doty, *Will Barnet* (New York: Harry A. Abrams, Inc., 1984), 111-43.

[2] *World in a Frame: Drawings by Will Barnet, Poems by Emily Dickinson*, intro. Christopher Benfey (New York: George Braziller, Inc., 1989). See Barnet's illustration on page 93, which accompanies Poem No. 1400, "What mystery pervades a well!"

[3] For a discussion of the issue of framing in Barnet's Dickinson works, see Benfey's introduction to *The World in a Frame*, vii-xiv.

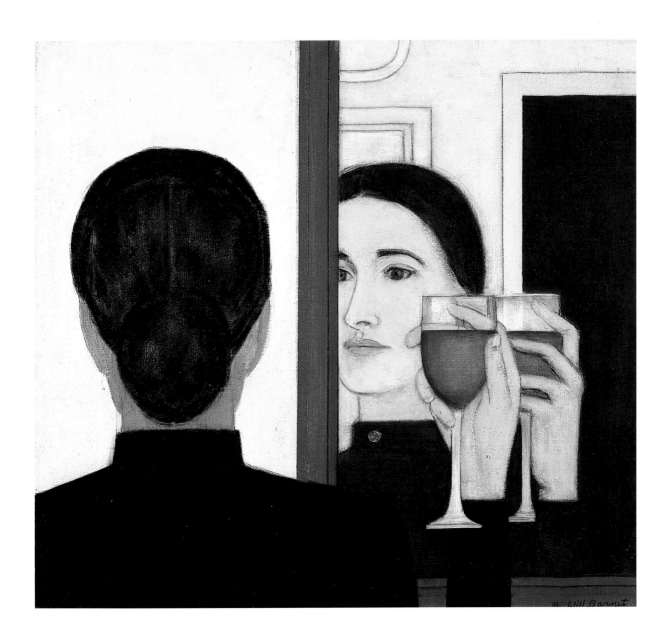

Between the form of Life and Life
The difference is as big
As Liquor at the Lip between
And Liquor in the Jug
The latter—excellent to keep—
But for ecstatic need
The corkless is superior—
I know for I have tried

(P 1101)

Judy Chicago

(b. 1939)

Plate No. 5

Emily Dickinson Plate
(Model for *The Dinner Party*), 1979
Lace and hand-painted ceramic
14 in. diameter
Mead Art Museum
Gift of J. Thomas Harp

JUDY CHICAGO'S MONUMENTAL INSTALLATION piece, *The Dinner Party*, is one of the most publicized works of feminist art. It consists of a triangular table with place settings for thirty-nine women chosen because of their historical accomplishments or legendary powers. Chicago explained the inclusion of Emily Dickinson among these feminist luminaries as a choice based on both the circumstances of Dickinson's life and the importance of her unusual poetic language. Chicago sees Dickinson's life as controlled by her father, her poetry as socially "dangerous," and the hand-stitched fascicles of poems hidden away in a trunk as elements of Dickinson's biography deserving of a feminist interpretation.[1]

In *The Dinner Party*, each of the settings includes a ceramic plate decorated with a design based on the form of a butterfly, which according to Chicago symbolizes "liberation and the yearning to be free." The pink Emily Dickinson plate, with its frilly lace edges surrounding a red, vulva-shaped center, visually extends the notion of liberation into the sexual realm as well. In the test plate for the final piece, Chicago also included the first quatrain of the Dickinson poem cited below, further underscoring Chicago's belief in the ties between sexual liberation and female empowerment.

Like the delicate lace decoration that adorns the plate, the second stanza of Dickinson's poem ironically undercuts the notion of feminine strength. Chicago's deliberate choice of traditionally feminine art forms—china painting and embroidery—is similarly self-referential and deprecating. Her use of the butterfly imagery further relates to one of Dickinson's frequently used symbolic metaphors, one that appears in the first line of the next poem that appears in the standard anthology of her work: "Some such Butterfly be seen / On Brazilian Pampas" (P 541). Dickinson's exotic butterfly is elusive and ephemeral, but no less fraught with sexual connotations, "Some such Spice—express and pass— / Subject to Your Plucking— / As the Stars—You knew last Night— / Foreigners—This Morning—".

For Chicago, the layers of immobilized porcelain lace on the Dickinson plate represent the Victorian era's oppression of female spirit and serve as a reminder of the hours of labor "required to make these beautiful but unappreciated patterns by women who remain unknown."[2] Chicago ties Dickinson's life and work to the plight of working-class women during the Industrial Revolution, seeing the poet as a feminist writer "who began to articulate women's experiences from a woman's point of view."[3] Like other contemporary artists whose work draws on the broader implications of the poet's life, Judy Chicago was influenced by feminist literary criticism, especially the writings of Adrienne Rich. Rich has argued that one of Dickinson's most important contributions to modern culture is the way in which her poetry draws attention to "women's culture, a woman's tradition; and what the presence of other women meant in her life."[4]

[1] Judy Chicago, *The Dinner Party, A Symbol of Our Heritage* (Garden City, N.Y.: Anchor Press, 1979), 90-91.
[2] Chicago, *The Dinner Party*, 91.
[3] Chicago, *The Dinner Party*, 194; see also Judy Chicago, *Embroidering Our Heritage: The Dinner Party Needlework* (Garden City, N.Y.: Anchor Press, 1980), 234-41.
[4] Adrienne Rich, "Vesuvius at Home: The Power of Emily Dickinson," in *On Lies, Secrets, and Silence* (New York: W.W. Norton and Co., 1979), 158. Rich's writing also informs the work of Carla Rae Johnson and Aífe Murray.

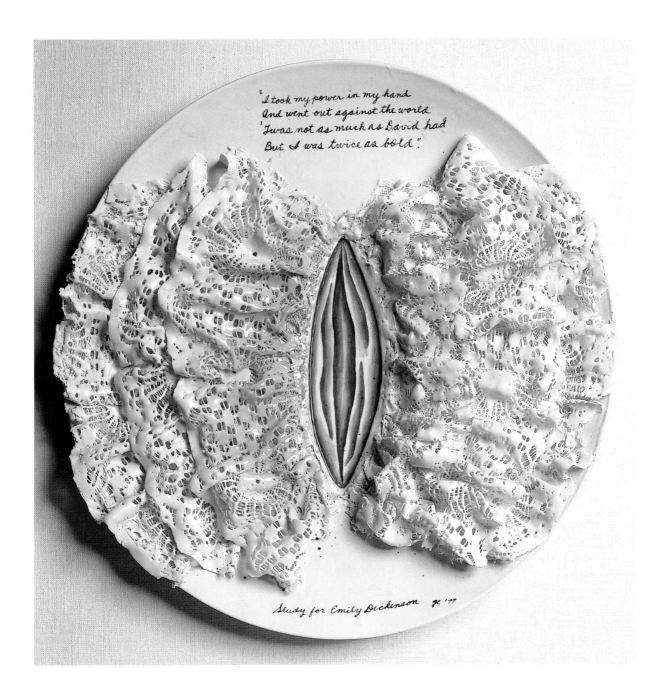

I took my Power in my Hand—
And went against the World—
'Twas not so much as David—had—
But I—was twice as bold—

I aimed my Pebble—but Myself
Was all the one that fell—
Was it Goliah—was too large—
Or was myself—too small?

(P 540)

Joseph Cornell

(1903-1972)

JOSEPH CORNELL'S ASSEMBLAGES include collage, film, and surrealist objects, together with a wide variety of box constructions that derive in basic ways from Victorian curiosity cabinets. From his home on Utopia Parkway in Flushing he regularly ventured to the galleries, theaters, and opera houses in Manhattan as well as to bookshops and flea markets. His interest in Emily Dickinson was part of his abiding fondness for particular artists, poets, ballerinas, divas, and movie stars. Diary entries, letters, and his collection of Dickinson books reflect a devotion that began with his early studies in a Massachusetts preparatory school and then his reading of Marsden Hartley's *Adventures in the Arts*, published in 1921, where the poet is said to be "scintillant with stardust."[1]

Dickinson's creation of daring metaphors and images that prompt the mind's farthest explorations was Cornell's practice as well, what he called the "ecstatic voyaging" of the imagination.[2] "My Basket," Dickinson wrote, "holds—just— Firmaments—" (P 352). Artists, whatever the medium, were for both Joseph and Emily "those that Magic make—" (P 1585). Cornell often fixed on biographical details of the artists he revered. In the case of Dickinson, it was the arresting daguerreotype he encountered in a book, the carefully copied poems she tied into the fascicles he saw in a display case in the Morgan Library in New York, and the fact that she kept her poem packets in a box in a drawer of the dresser in her bedroom.

The Cornell box *"Toward the Blue Peninsula" (for Emily Dickinson)* represents the stark seclusion of the poet's room, with a window onto a star splashed firmament through which the imagination, like a bird, soars to exotic places, in this case Italy. Joseph had read in a biography that the "blue peninsula" where Dickinson feared one might "perish—of Delight" (P 405) was her novel image for the exotic Mediterranean land a dear friend of hers had set out from Amherst to visit.

An untitled Chocolat Menier box (Grey Art Gallery and Study Center, New York University) is linked to Dickinson by the chocolate wrapper, Cornell having discovered in his reading, to his delight, that Dickinson scratched quick drafts of her poems on paper scraps, including the Chocolat Menier packet in the pantry. In addition to the magical conjuring words in the box, there is a conspicuously placed string that may have once attached a bird to its perch. The warbler out of sight behind the partition is the poet, who, by her early thirties was rarely seen by strangers, even by the neighbor who came to play the piano for her while Emily sat at the top of the stairs out of sight.

Some of Cornell's many "Hotel" boxes also relate to Dickinson because they summon the dream of distant travels. In the instance of the Mead Art Museum's box, this deserted habitat symbolizes the mystical unimportance of the corporeal body when the bird sings or the human mind soars. Joseph's sister, Elizabeth, who shared his deep affection for the poet, presented the box to the museum as evidence of their respect for the poet's hometown and for the college the poet's grandfather helped found in 1821.

That Cornell felt his life was intimately associated with Dickinson's is evidenced by a small trinket box filled with Christmas tree ornaments, now in the collection of the Cornell Archives at the National Museum of American Art. The worn box holds several tiny gold balls that Cornell found at an antiques fair in New York and placed with his sister's wedding announcement cut into a little holiday tree. The assembled objects speak eloquently of his sister's shared passion for Dickinson and of the family holidays that Cornell loved as a child. They link his own birthday with Dickinson's in the Christmas season. With the box is a note in Joseph's hand that reads "As tho made by E.D."

Serving as symbols of the manuscript treasures Dickinson kept in a box in her bedroom for her sister, Lavinia, to find, Cornell's boxes also materialize Dickinson's unique poetics in a way that pictures or narrative cannot. His compactly assembled objects, like her spare words, make, to use the poet's phrase, "amazing sense from ordinary Meanings" (P 448). The constructions of both artists, notably the syntactical puzzles in the poems and the riddling juxtapositions in the boxes, preserve a spontaneity and secretiveness that test the generic orthodoxies, confounding us to our immense pleasure.

[1] The most complete studies of Cornell's work are Dore Ashton, *A Joseph Cornell Album* (New York: Viking, 1974); Diane Waldman, *Joseph Cornell* (New York: Braziller, 1977); and *Joseph Cornell*, ed. Kynaston McShine, exhibition catalogue (New York: The Museum of Modern Art, 1980).

[2] For a more detailed study of these two artists see David Porter, "Assembling a Poet and Her Poems: Convergent Limit-Works of Joseph Cornell and Emily Dickinson," *Word and Image* 10, no. 3 (1994): 199-221.

It might be lonelier
Without the Loneliness—
I'm so accustomed to my Fate—
Perhaps the Other—Peace—

Would interrupt the Dark—
And crowd the little Room—
Too scant—by Cubits—to contain
The Sacrament—of Him—

I am not used to Hope—
It might intrude upon—
Its sweet parade—blaspheme the place—
Ordained to Suffering—

It might be easier
To fail—with Land in Sight—
Than gain—My Blue Peninsula—
To perish—of Delight—

(P 405)

Plate 6

Joseph Cornell

"Toward the Blue Peninsula" (for Emily Dickinson), 1953

Mixed media

14 1/2 x 10 1/4 x 5 1/2 in.

Collection of Mr. and Mrs. Robert Lehrman, Washington, D.C.

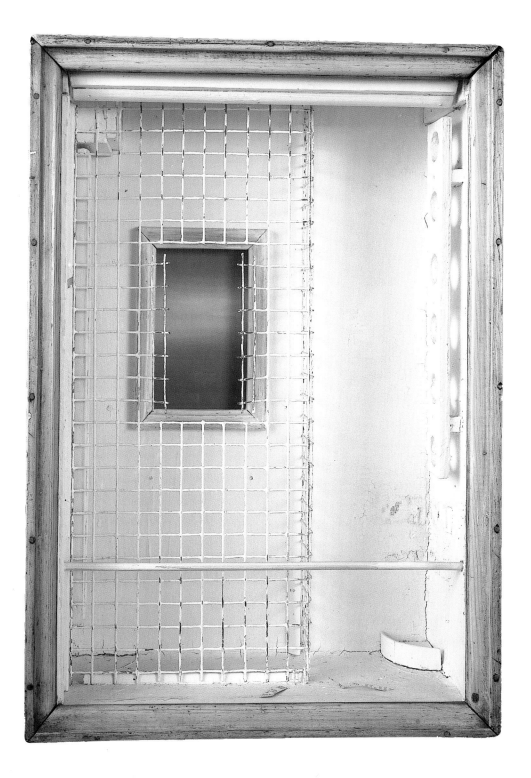

Robert Cumming

(b. 1943)

Plate 7

Smooth Mind, 1989
Lithograph
27 x 22 in.
Collection of the
artist

ROBERT CUMMING'S SERIES of four lithographic prints, *Smooth Mind, Eye Content, Upon the Head,* and *Knowing/Not Seeing*, is based on a Dickinson poem about emotion and intellect. Appropriating her text in an unusual manner, Cumming has selected phrases from the second stanza of the poem to use as captions for the enigmatic objects he invents. Each print depicts a single, three-dimensional form shrouded in shadow; and in each the lettering below is barely decipherable (see pl. 7). Identity and legibility lie at the heart of these works, as Cumming paraphrases Dickinson in his title for the last work in the series—*Knowing/Not Seeing*. Like the imagery in many of his paintings and sculptures, the elusive objects in these prints are rendered with an engineered precision, yet ultimately they remain undefinable. They are, however, based on real things: an apothecary's mortar, a rocket engine, a pencil, and a spindle from a New England mill. The grouping is quite deliberate and makes reference to the circumstances of the artist's own life.

Born in Worcester, Massachusetts, Cumming now lives in the Connecticut River Valley, not far from the town of Amherst. In his early career during the 1970s, he worked in California, where issues of text and image were a particular concern of other postmodern artists such as the painter-printmaker Ed Ruscha and photographer Robert Heinecken. After Cumming returned to New England in the 1980s, he began to create emblems and stories related to a mythical, nineteenth-century mill town.[1] Throughout his artistic career, Cumming has also written a great deal—letters, short stories, and a book on naval architecture—literary works in which he often integrates words and text. His Emily Dickinson prints are yet another means by which he attaches a poetic quality to relics of industrial production.[2] Like Dickinson's poetry, Cumming's visual imagery is deceptively simple and forever suggesting multivalent meaning.

[1] From 1980 to 1985, Cumming worked on an unfinished novel about this mill town; for details, see Hugh M. Davies and Lynda Forsha, "A Conversation with Robert Cumming," in *Robert Cumming, Cone of Vision*, exhibition catalogue (San Diego: Museum of Contemporary Art, 1993), 35.

[2] See Cumming's comments in *Robert Cumming*, exhibition catalogue (New York: Castelli Graphics, 1988), n. 7. There he relates Dickinson's poetry to the larger issue of regional identity in American landscape painting and his own fascination with Thomas Cole's painting *The Oxbow* (1836) at the Metropolitan Museum of Art.

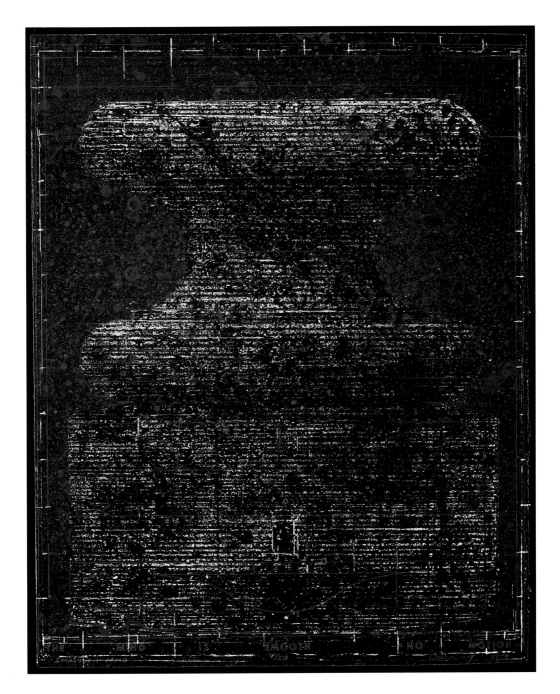

The difference between Despair
And Fear—is like the One
Between the instant of a Wreck—
And when the Wreck has been—

The Mind is smooth—no Motion—
Contented as the Eye
Upon the Forehead of a Bust—
That knows—it cannot see—

(P 305)

Lesley Dill

(b. 1950)

Plate 8

Poem Hands (Double)— ["*Palpé mi vida, con dos mi manos*"]

["I felt my life with both my hands," Poem no. 351], 1995

Ink, tea, oil paint, shellac, thread, wire on gauze

309 x 41 in.

Courtesy of George Adams Gallery, New York

OVER THE PAST SEVEN YEARS Lesley Dill has produced a significant body of work related to the words and life of Emily Dickinson. Dill's art includes prints, sculptures, banners, and performance pieces that focus on images of the body, but also suggest various states of the mind. Writing about the use of text in her work, Dill has noted, "I think of words, and especially the poems of Emily Dickinson, for their embodiment of psychological states of despair and euphoria as metaphors for being, as a kind of spiritual armor, an intervening skin between ourselves and the world."[1]

In her prints and banners, Dill literally incorporates Dickinson poems into her work by inscribing the texts on the bodies of studio models whom she then photographs. For her sculptures, the letters are often cut out of sheet metal or shaped of bent wire. The forms of the letters are frequently obscured by the three-dimensional shapes onto which they have been stenciled, cut-out, or written in free-hand (see fig. 9). The difficulty of reading these transcribed poems adds to the emotional aura of Dill's work.

In a recent series of fabric banners that include *Poem Hands (Double)* (pl. 8) and *Rolled Up Poem Girl*, Dill appropriates Dickinson's words to focus on issues of race and gender. The Spanish text in *Poem Hands (Double)* and the nude black model in *Rolled Up Poem Girl* suffuse the original text with new meaning. The texts when combined with images of the naked body relate not only to the idiosyncratic personality of the Victorian poet, but to larger contemporary social concerns about cultural identity and empowerment as well.

In other works, Dill represents the complex relationship of body, language, and sexuality through references to dress.[2] The life-sized, freestanding *White Poem Dress* uses the negative space of cut-out letters to suggest the absent female body within the sculpture (see pl. 1). *Paper Poem Torso*, with its cascade of letters flowing from the bottom of a fragile paper T-shirt, visually conveys the sense of the Dickinson poem stamped across the front of the shirt: "Exhilaration—is within— / There can no Outer Wine / So royally intoxicate." The two cut-out holes in the midsection of the shirt, suggestive of nipples, further link this work to the sexual allusions in the last stanza: "To stimulate a Man / Who hath the Ample Rhine / Within his Closet—Best you can / Exhale in offering."

Dill is not alone in the use of clothing and the body as the basis of her art,[3] but in appropriating Dickinson's words as a subtext, she widens the meaning of these forms. Her white poem dresses and hanging cloth banners contain specific references to Dickinson's virginal, Victorian garb, as well as to a culture half-way round the world. While living in India in 1992, Dill saw Buddhist prayer flags flying in the wind and heard the (to her) unintelligible sounds of Hindi incantations. Since that experience, Dill has tried to link sensory experience of the ephemeral with Dickinson's poetry: "This World is not Conclusion. / A Species stands beyond— / Invisible as Music— / But positive, as Sound" (P 501). The ghostly figures that appear on her banners of scrim and tea-stained muslin convey a similar sense of the transitory.

[1] Artist's statement, "Poem Sculptures," 1994, in exhibition files, Mead Art Museum.

[2] For further discussion of Dill's work, see the exhibition reviews by Janet Koplos, "Lesley Dill at Gracie Mansion," *Art in America* 82 (Oct. 1994): 137, and Suzannah Rich, "Skin of Words: Leslie [*sic*] Dill's Poem Sculptures," *Emily Dickinson International Society Bulletin* 5 (Nov.-Dec. 1993): 4-5, 15.

[3] A recent issue of *Art Journal* was devoted entirely to the subject of clothing in contemporary art and included a description of one of Dill's Dickinson dresses used in a performance piece at the 1994 Dada Ball, a benefit for Visual AIDS and Housing Works (see *Art Journal* 54 [Spring 1995]: 84-85.

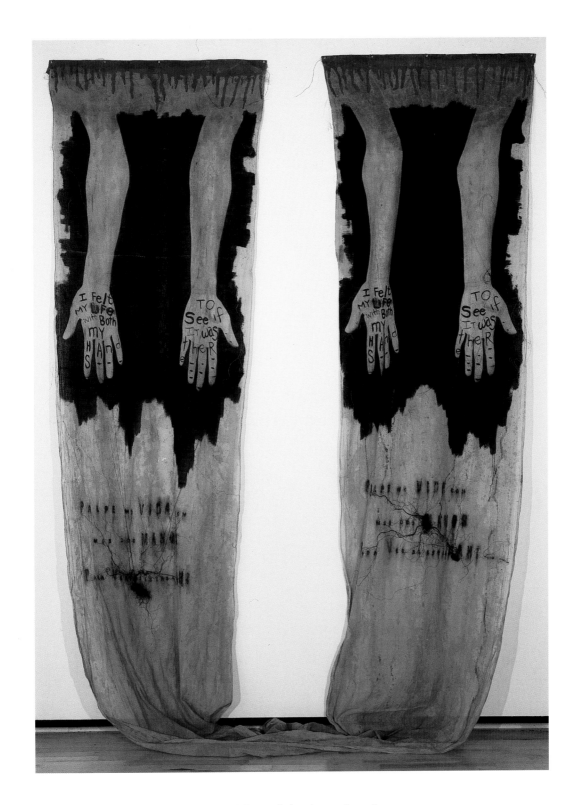

I felt my life with both my hands
To see if it was there—
I held my spirit to the Glass,
To prove it possibler—

(P 351)

Mary Frank

(b. 1933)

Plate 9

Head in Fish, 1994
Cut paper
8 1/4 x 12 in.
Lent by Elena Zang
Gallery

BECAUSE EMILY DICKINSON TRAVELED infrequently and shunned the social niceties of visits with her Amherst neighbors, she has often been called a recluse. As this poem makes clear, however, Dickinson delighted in sharing with her readers journeys of the imagination, especially through her nature poetry. Mary Frank also conveys an inventive notion of poetic travel in her paper cutouts, especially this image of a human figure incorporated into the body of a fish. The fish-figure seems to swim or even fly in a luminous space created by lines of light filtering through the slits in the paper. Executed as an illustration for a book of Dickinson's nature poetry, this particular cutout also suggests the close relationship between image and text that Mary Frank hoped to achieve: "I wanted each image to be as austere and yet as full as Emily Dickinson's poem. She can take the most wrenching feelings and put them into five or six words. What an ability—to bring the outside world in and the inside world out to meet it!"[1]

An artist best known as a sculptor and printmaker,[2] Mary Frank chose an unusual, but appropriate, medium for these illustrations—an art form that has special resonance for nineteenth-century literature. Cut-paper images in the form of portrait silhouettes and figural shapes known as papyrotamia were very popular in Victorian America.[3] As a young girl, Dickinson had her silhouette done by her tutor (see fig. 14). Mary Frank describes her own use of the medium as "a dance with the paper," an apt reference given her early training as a dancer with Martha Graham in the late 1940s. An avid reader as a child, Mary Frank had her first extended encounter with Dickinson when she saw a performance of Graham's "Letter to the World" and purchased Barbara Morgan's book of photographs that includes scenes of the dance (see pl 13).

[1] Mary Frank in *Skies in Blossom: The Nature Poetry of Emily Dickinson*, ed. Jonathan Cott, illus. Mary Frank (New York: Doubleday, 1995), 97.

[2] For a lengthier discussion of Frank's work and its relationship to images of nature, see *Natural Histories*, exhibition catalogue (Lincoln, Mass.: DeCordova Museum, 1988) and Hayden Herrera, *Mary Frank* (New York: Harry N. Abrams, 1990).

[3] For example, the prolific book illustrator Hammatt Billings made papyrotamia, cut-paper figures of horses, animals, and landscapes onto which he cast light to make shadow puppets, see James F. O'Gorman, "War, Slavery, and Intemperance in the Book Illustration of Hammatt Billings," *Imprint* 10 (1985): 2-10. See also Alice Van Leer Carrick, *A History of American Silhouettes* (Rutland, Vt.: C. E. Tuttle, 1968).

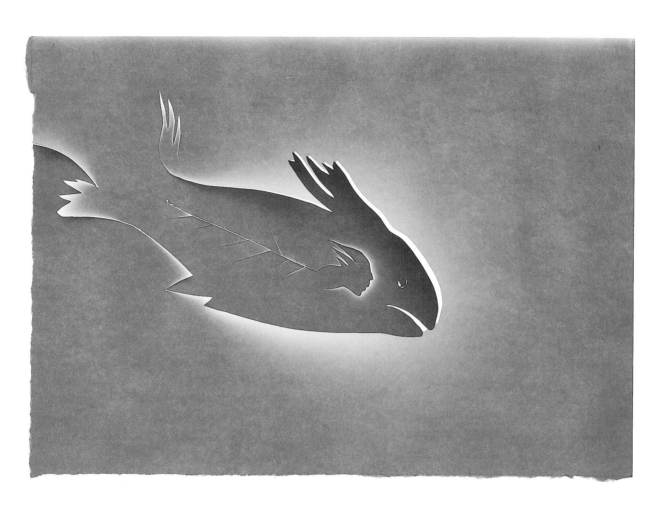

"Go traveling with us!"
Her travels daily be
By routes of ecstasy
To Evening's Sea—

(P 1513)

Roni Horn

(b. 1955)

Plate 10

How Dickinson Stayed Home, 1992-93

Plastic and aluminum, "3/3"

Dimensions variable

Museum installation, 5 in. x 23 ft. x 16 ft.

The Museum of Modern Art, Gift of Agnes Gund, 1993

FOR THIS SCULPTURE RONI HORN uses individual blocks of letters to spell out "My Business is Circumference," a phrase excerpted from a letter Dickinson wrote to the Boston editor Thomas Wentworth Higginson in July 1862. In the 1860s and 1870s, Higginson served as Dickinson's literary mentor, or as she called him, her Preceptor. His response helped her to understand how far her poems stood outside the boundaries of the conventional poetry of her day—"the only Kangaroo among the Beauty." She consciously navigated around the hazards of literary "Customs." She stayed at home and kept her poems private, as the title of Horn's work indicates.

Horn incorporates her audience into this poetic process of "circumference" by visually disconnecting the usual syntax of Dickinson's language. Each blue plastic letter of "My Business is circumference" is cast into its own three-dimensional aluminum block and stands alone. Horn distributes the blocks (seemingly at random) across the floor, as she says, to force "the viewer into a physically dynamic reading of the text—a movement that is a metaphor for engagement."[1] It is left to the viewer or reader to recognize the Dickinson phrase and reconstruct its meaning.

However unlikely it may seem, Roni Horn began her own intense engagement with Emily Dickinson's language on a trip to Iceland in 1992.[2] The only book she took along on that journey of self-imposed isolation was Dickinson's complete works. In a short essay about her Iceland work for an exhibition entitled *Inner Geography*, Horn suggests how her experience of travel to that remote and desolate region relates to Dickinson's poems and letters: "Her writing is an equivalent of this unique island; Dickinson invented a syntax out of herself, and Iceland did too. Volcanos do. Dickinson stayed home to get at the world."[3] Since that trip, Horn has produced a number of works devoted to Dickinson poems. They include the series comprising aluminum bars with letters that replicate individual lines from sets of quatrain verses (*When Dickinson Shut Her Eyes*, 1993), a group of single opening lines (*Keys and Cues*, 1994), and an eleven-foot-high stack of letters (*Untitled [Gun]*, 1994) which spells out one of Dickinson's most frequently used lines "My Life had stood a loaded Gun."[4] This famous phrase also appears in Linda Schwalen's work (see pl. 16).

[1] Roni Horn, "Among Essential Furnishings," in *Earths Grow Thick*, exhibition catalogue (Columbus: Wexner Center for the Arts, Ohio State University, 1995), 82. This essay, prompted by a series of questions posed by Judith Hoos Fox, appears in the Wexner Center catalogue of Horn's Dickinson pieces. The catalogue also includes an essay by the contemporary poet bell hooks, "between us: traces of love—Dickinson, Horn, hooks," 57-63.

[2] For a lengthier discussion of the relationship of Dickinson, Horn, and Iceland, see Amada Cruz, "Similar Things in Different Forms," in *Earths Grow Thick*, 85-90.

[3] Roni Horn, "When Dickinson Shut Her Eyes," *Island* (Baltimore: Baltimore Museum of Art, 1994), 14. Horn frequently creates books filled with her photographs and writings to accompany exhibitions of her drawings and sculptures. Like Dickinson's current critics, she is very conscious of the relationship between handwritten fascicles and the appearance of poetry in printed typography.

[4] For a discussion of these works see Sarah J. Rogers, "Places between Words," in *Earths Grow Thick*, 93-99, and Charles Wylie, *Roni Horn*, exhibition brochure (St. Louis: Saint Louis Art Museum, 1995); and for her work in general see Nancy Spector, "Being Double," *Roni Horn*, exhibition catalogue (Tilburg, Holland: De Pont Foundation for Contemporary Art, 1994), 57-65.

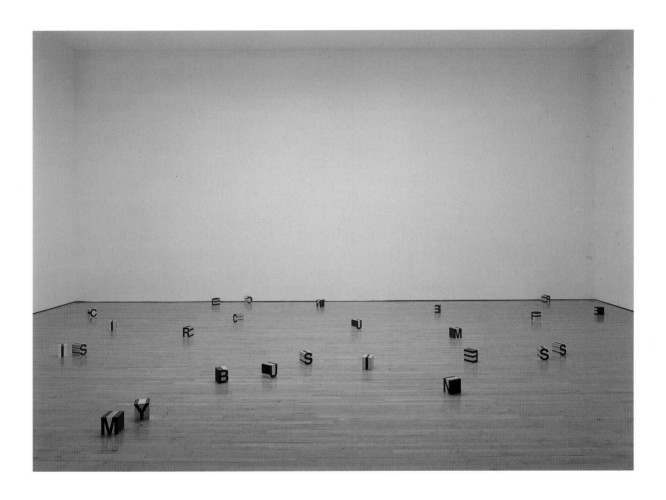

My Business is Circumference—An ignorance, not of Customs,
but if caught with the Dawn—or the Sunset see me—
Myself the only Kangaroo among the Beauty . . .

(L 268)

Carla Rae Johnson

(b. 1947)

Plate 11

Lectern for Emily Dickinson (front view), 1994

Wood and mixed media

89 x 54 x 64 in.

Collection of the artist

VOLCANOES APPEAR WITH SOME FREQUENCY in the poetry of Emily Dickinson.[1] Like Dickinson's "reticent volcano" and "Vesuvius at Home," Carla Rae Johnson's volcano threatens to erupt in the midst of a domestic setting. Hidden underneath a flight of stairs, it burns like "A still—Volcano—Life—" or "A quiet—Earthquake Style—" (P 601). The literary and social context for Johnson's work is further linked through the image of the volcano to contemporary feminist criticism, especially that of the poet Adrienne Rich. In a 1975 essay, "Vesuvius at Home: The Power of Emily Dickinson," Rich writes of Dickinson's need to "retranslate her own unorthodox, subversive, sometimes volcanic propensities into a dialect called metaphor; her native language. 'Tell all the Truth—but tell it Slant—.' It is always what is under pressure in us, especially under pressure of concealment—that explodes in poetry."[2]

The Dickinson lectern is part of a larger installation that invokes the presences of three other notable women: Virginia Woolf, Harriet Tubman, and Sojourner Truth. For each of these figures, Johnson has fabricated a lectern whose shape suggests the meaning of their words.[3] The Dickinson lectern incorporates a staircase that leads nowhere. It stands, however, as a visual metaphor for the real space in Emily Dickinson's house, the stairs leading to the second-floor bedroom where the poet composed much of her work. Johnson intends her viewers to see these scaled-down stairs as a platform from which we can imagine a "reading" of the poems.

The installation has a spoken component, as well, a videotape in which the artist reads an imaginary letter from the poet to the audience.[4] This video performance enhances the allusion to a lectern and further suggests another architectural form created for speech, the pulpit reached by a switchback stair found in traditional New England churches. Although Dickinson adamantly refused to participate in church-bound forms of worship, her poem about the reticent volcano relies on religious metaphors to deal with the human implications of death; and she often wrote about the religion of nature.

[1] See also, for example, Poems 601, 754, 1705, and 1677.

[2] Adrienne Rich, *On Lies, Secrets, and Silence: Selected Prose 1966-1978* (New York: W.W. Norton and Co., New York, 1979), 161-62. The ideas in this essay were originally presented as a lecture at Brandeis University.

[3] The installation that included these works, "Spirit and Substance, Sculptural Lecterns and the Spoken Word," was shown at SoHo 20 Gallery in New York, March 29-April 23, 1994. The Sojourner Truth piece consisted of a figure of a female slave with a freedom plow; Virginia Woolf was represented by a overscaled pen nib; and Harriet Tubman's presence was conveyed by a cow-catcher and a patchwork quilt, symbols of the Underground Railroad.

[4] The text of this imaginary letter is composed of excerpts from various Dickinson's letters and poems chosen, as Johnson has said, because of their relevance to modern audiences.

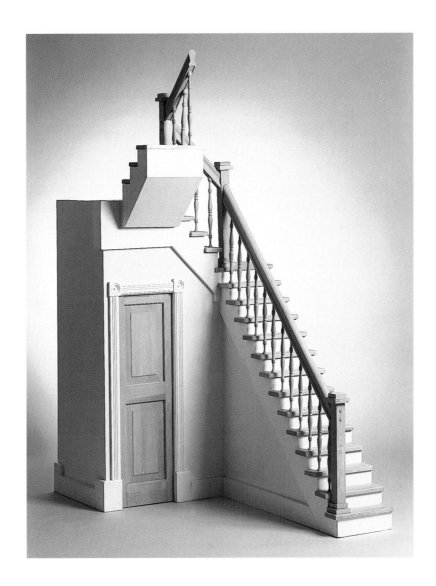

The reticent volcano keeps
His never slumbering plan—
Confided are his projects pink
To no precarious man.

If nature will not tell the tale
Jehovah told to her
Can human nature not survive
Without a listener?

Admonished by her buckled lips
Let every babbler be
The only secret people keep
Is Immortality

(P 1748)

Paul Katz

(b. 1942)

Plate 12

I reason, Earth is short,
1993

Oil and sand on
canvas

30 x 30 in.

Collection of the
artist

PAUL KATZ'S WORD PAINTINGS can be read individually or seen from afar as a series, just as Emily Dickinson's poems can be read line by line or viewed in their fascicles as sequential parts of a whole object. Each artist begins with the idea of the simple and concrete, and then, through the act of making language visible, complicates the written text. Emily Dickinson disguises her complex metaphors with another kind of calculated simplicity—by the terseness of her lines and her purposeful choice of dashes over traditional forms of punctuation. Katz complicates his text by running the Dickinson lines, without any punctuation, from top to bottom and edge to edge on the canvas, and by uniformly printing the poem in small red block letters across the black background.

It is not only the written form of Emily Dickinson's words that have captured Katz's imagination. As he describes it, "I was drawn to Emily Dickinson because of her preoccupation with final things. Like a child she pondered those big scary thoughts of death and eternity. Unlike the child, she fashioned her ecstatic speculations into verbal patterns we call poems as I fashion her words into other patterns called paintings."[1] Like Roni Horn's travels to Iceland, Katz's visit to an unlikely place—an Umbrian graveyard filled with ancient memorial plaques—was the initial inspiration for his Dickinson paintings. Unable to read the Italian inscriptions, he began to view the texts as abstract surface decorations which "tease us out of thought," an idea Katz relates to John Keats's poem, "Ode on a Grecian Urn."

Throughout his career, Katz has been involved in writing as well as painting. While working in New York as a photographer and art dealer, he edited a publication of artists' writings, *Art Now: New York 1969-71*. More recently, in an outdoor piece installed at Bennington College, Katz placed small iconic paintings and excerpts from the poetry of Wallace Stevens, A. E. Housman, and Gerard Manley Hopkins on plaques which were nailed high up on trees in a woodland setting. Viewers were invited to wander down a footpath to look for these tiny word-works hidden in the trees.[2] Simultaneously in search of nature and art, his viewers took part in an activity not unlike that experienced by Emily Dickinson, who looked for poetic inspiration in her own garden. Katz also used images of trees and selections of poetry for an indoor installation at Bennington that was held in conjunction with the college's annual writing workshop. There, as in his Dickinson pieces, the paintings contained tree shapes created from subtle variations in the texture of the gritty paint surface. Katz's association of Dickinson with nature imagery is further evident in the two artist's books in which he has illustrated her poetry with clouds and trees.

[1] Artist's statement, 12 September 1995. See the Emily Dickinson exhibition file, Mead Art Museum.
[2] *Bennington Banner*, 28 April 1994. Katz currently lives in North Bennington, Vermont, and exhibits frequently in that area; for additional reviews of his recent work see Tom Fels, *Bennington Banner*, 27 July 1995, and Paul Stitelman in *Art New England* 15 (Aug.-Sept. 1994): 71 and 16 (Feb.-March 1995): 53 (in the Emily Dickinson exhibition file, Mead Art Museum).

I REASON EARTH IS SHORT AND ANGUISH ABSOLUTE AND MAN
Y HURT BUT WHAT OF THAT I REASON WE COULD DIE THE BES
T VITALITY CANNOT EXCEL DECAY BUT WHAT OF THAT I REA
SON THAT IN HEAVEN SOMEHOW IT WILL BE EVEN SOME NEW
EQUATION GIVEN BUT WHAT OF THAT I REASON EARTH IS
SHORT AND ANGUISH ABSOLUTE AND MANY HURT BUT W
HAT OF THAT I REASON WE COULD DIE THE BEST VITALIT
Y CANNOT EXCEL DECAY BUT WHAT OF THAT I REASON
THAT IN HEAVEN SOMEHOW IT WILL BE EVEN SOME NEW
EQUATION GIVEN BUT WHAT OF THAT I REASON EARTH IS
SHORT AND ANGUISH ABSOLUTE AND MANY HURT BUT WHA
T OF THAT I REASON WE COULD DIE THE BEST VITALITY CAN
NOT EXCEL DECAY BUT WHAT OF THAT I REASON THAT IN H
EAVEN SOMEHOW IT WILL BE EVEN SOME NEW EQUATION
GIVEN BUT WHAT OF THAT I REASON EARTH IS SHORT AND AN
GUISH ABSOLUTE AND MANY HURT BUT WHAT OF THAT I RE
ASON WE COULD DIE THE BEST VITALITY CANNOT EXC
EL DECAY BUT WHAT OF THAT I REASON THAT IN HEAVE
N SOMEHOW IT WILL BE EVEN SOME NEW EQUATION GIVEN
BUT WHAT OF THAT I REASON EARTH IS SHORT AND ANGU
ISH ABSOLUTE AND MANY HURT BUT WHAT OF THAT I RE
ASON WE COULD DIE THE BEST VITALITY CANNOT EXCEL
DECAY BUT WHAT OF THAT I REASON THAT IN HEAVEN
SOMEHOW IT WILL BE EVEN BUT WHAT OF THAT SOME
NEW EQUATION GIVEN BUT WHAT OF THAT I REASON EART
H IS SHORT AND ANGUISH ABSOLUTE AND MANY HURT BUT WH
AT OF THAT I REASON WE COULD DIE THE BEST VITALITY
CANNOT EXCEL DECAY BUT WHAT OF THAT I REASON THAT
IN HEAVEN SOMEHOW IT WILL BE EVEN SOME NEW EQUAT
ION GIVEN BUT WHAT OF THAT I REASON EARTH IS SHORT
AND ANGUISH ABSOLUTE AND MANY HURT BUT WHAT OF
THAT I REASON WE COULD DIE THE BEST VITALITY CAN
NOT EXCEL DECAY BUT WHAT OF THAT I REASON THAT IN
HEAVEN SOMEHOW IT WILL BE EVEN SOME NEW EQUATIO
N GIVEN BUT WHAT OF THAT I REASON EARTH IS SHO
RT ANGUISH ABSOLUTE AND MANY HURT BUT WHAT O

I reason, Earth is short—
And Anguish—absolute—
And many hurt,
But, what of that?

I reason, we could die—
The best Vitality
Cannot excel Decay,
But, what of that?

I reason, that in Heaven—
Somehow, it will be even—
Some new Equation, given—
But, what of that?

(P 301)

Barbara Morgan

(1900-1992)

Plate 13

*Letter to the World
(Kick)*, 1940

Gelatin silver print

15 1/4 x 19 1/2 in.

Smith College
Museum of Art

IN THE SPRING OF 1941, shortly after she completed the choreography for a dance based on Emily Dickinson's poems, Martha Graham made a pilgrimage to the Dickinson Homestead.[1] A phrase from the opening line of Dickinson's poem "This is my letter to the World" served as the title of the work and a spoken text accompanying the dance derived from a number of other Dickinson poems. In *Martha Graham, Sixteen Dances in Photographs*, published the following year, the photographer Barbara Morgan also included excerpts from Dickinson's poetry as captions for her pictures.[2] A complex interplay of text, performance, and visual image is thus embedded in one of Morgan's best known photographs,[3] often referred to as *Kick*, an evocative image of Graham captured as the upward swing of white dress creates a swirl of movement.

The white dress designed by Graham evokes the simple attire worn by Dickinson during the last years of her life. Graham's character, called "The One Who Dances," is, however, only one manifestation of Dickinson's personality. Other female dancers in the cast, "The One who Speaks," "The Children," "The Young Girl," and "The Fairy Queen," express different aspects of the poet's life: language, childhood, adolescence, and imagination. "The Ancestress" represents the poet's Puritan New England heritage, as well as her concern with death.[4] The real drama of the dance centers on the male roles "Lover" and "March," originally performed by Erick Hawkins and Merce Cunningham, respectively. When the men disappear from the scene, chased out by "The Ancestress," the various Dickinson personae turn to poetic expression as a means of emotional fulfillment. Despite the underlying romanticism of this narrative interpretation of Dickinson's life and work, Graham's dance is one of the earliest attempts to visualize the poet's minimalist aesthetic. In the simple dramatic gestures, spare stage sets, and bold effects of lighting, the dance assumes an austerity and precision that is ultimately poetic.

Barbara Morgan adapted Graham's modernist stance in dealing with the intermingling of poetry and dance. She relied on the camera's ability to arrest motion by focusing on the dancers' leaps and the activated fabric of their costumes. Her use of black-and-white photography further served to enhance the intensity of these images by sharply contrasting the white costumes against the dark walls of the sparsely decorated set. The resulting pictures convey Morgan's overriding interest in what she termed the "Rhythmic Vitality" of external forms.[5] Like the deceptive simplicity of Dickinson's spare quatrains and Graham's poetic choreography, Morgan's photographs also manage to suggest the complexity and intensity of human emotion.

[1] According to the guestbook kept by the Parke family, who owned the Homestead from 1916 to 1965, Graham visited the house 14 April 1941. I am grateful to Cindy Dickinson, curator of the Homestead, for providing this information.

[2] Barbara Morgan, *Martha Graham: Sixteen Dances in Photographs* (1941; rev. ed., Dobbs Ferry, N.Y.: Morgan and Morgan, 1980).

[3] This photograph is often reproduced as the quintessential Morgan dance subject. See Lee D. Witkin and Barbara London, *The Photograph Collector's Guide* (Boston: New York Graphic Society, 1979), 196. Andy Warhol also used Morgan's photograph for one of the three silk-screened posters published by the Martha Graham Center of Contemporary Dance in 1986.

[4] The visualization of the "Ancestress" was based on Graham's memory of her own great-grandmother, who, as she put it, "tried to make proper young ladies of all of us." See Martha Graham, *Blood Memory* (New York: Doubleday, 1991), 24.

[5] For a discussion of Morgan's dance photography in general, see Curtis L. Carter, "Barbara Morgan, Philosopher/Poet of Visual Motion," in *Barbara Morgan, Prints, Drawings, Watercolors, and Photographs*, exhibition catalogue (Milwaukee, Wis.: Patrick and Beatrice Haggerty Museum of Art, 1988), 17-20.

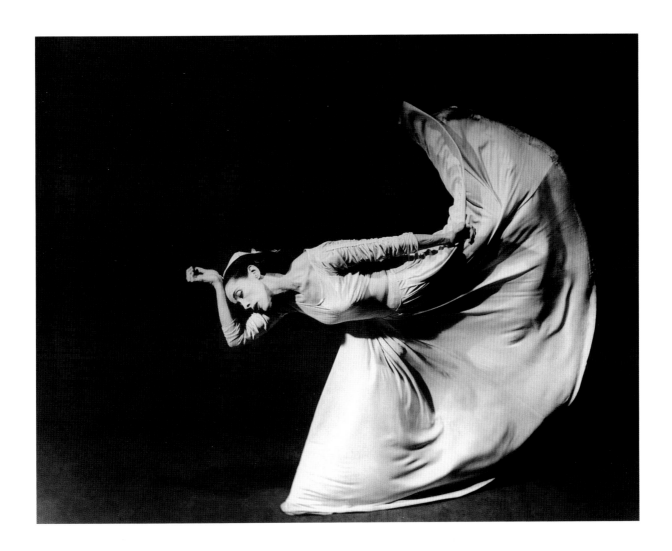

This is my letter to the World
That never wrote to Me—
The simple News that Nature told—
With tender Majesty

Her Message is committed
To Hands I cannot see—
For love of Her—Sweet—countrymen—
Judge tenderly—of Me

(P 441)

Aífe Murray

(b. 1953)

Plate 14

Pantry DRAWer (from *Kitchen Table Poetics—Maid Margaret Maher and Her Poet Emily Dickinson*), 1993-95

Mixed media installation

64 x 42 x 22 in.

Collection of the artist

AÍFE MURRAY IS A FEMINIST WRITER AND ARTIST whose fascination with Emily Dickinson is based on both her poetry and the circumstances of her domestic life. In the installation titled *The Pantry DRAWer* and in her artist's book *Kitchen Table Poetics—Maid Margaret Maher and Her Poet Emily Dickinson*[1] Murray explores the close relationship between Dickinson and the Irish-born servants in the poet's home. That relationship ultimately saved Dickinson's unpublished work from oblivion. Margaret Maher, a maid at the Dickinson Homestead, preserved some of the fascicles in a trunk, despite the poet's request to burn the poems after her death. Moreover, as Murray points out, it was Maher's household labor that allowed the poet the time and space to write. "This social aspect to the work of art is often invisible to the viewing public, but it is an ingredient. It is the *silence* that makes possible the *voice*. [Telling] the story of Maher and other servants in the life of Dickinson, is to put the roots and soil back onto the tree, making manifest—in a cross-cultural, cross-class context."[2]

Murray, who is also of Irish descent, intermingles disparate, iconic symbols of her Celtic heritage—a lion from the *Book of Kells* and a string of green plastic shamrocks—with everyday household objects: a box of Quaker Oats, a mop, an old drawer filled with flatware and poems. In another drawer and on an ironing board cover the faces of Dickinson and her servants confront the viewer, along with a self-portrait of the artist wearing a crown in reference to Dickinson who often called herself a queen. Murray's use of *milagros* and other Catholic religious objects in this installation expands the issue of ethnic identity to include Hispanic culture.

The sources for Murray's work are as culturally diverse as the imagery contained within it. Assemblage art, such as *Pantry DRAWer*, has a strong tradition on the West Coast where Murray now lives.[3] In its concern with social issues and obsession with found objects, her work relates to that of Ed Kienholz, George Herms, and Betty Saar. Murray also acknowledges the influence of the Ukrainian conceptual artist Ilya Kabakov, whose room-sized assemblages of ordinary objects are meant to convey the everyday lives and individual personalities of his Moscow neighbors. Kabakov like Murray is a writer, and both provide lengthy texts and handmade books to accompany their installations. Murray's inexpensive self-published writings, which combine word and image, also relate to the contemporary "zine" phenomenon. Zines (short for magazines) are a populist or counterculture alternative to the phenomenon of the artist's book. These publications are produced and distributed by their makers, and Murray sees them as the modern equivalent of the poems that Dickinson gave away to her friends.[4]

[1] Produced in 1994, this self-published book contains color Xeroxes, poems, and a lengthy essay about Dickinson's domestic activities, the role of servants in nineteenth-century Amherst households, and the life of Margaret Maher, a servant in the Dickinson home from 1869 to 1899.

[2] "Artistic Statement of a Work-in-Progress," 4 November 1995, paper distributed to studio visitors. See the Emily Dickinson exhibition file, Mead Art Museum.

[3] Murray received her undergraduate degree from Hampshire College in Amherst, Massachusetts, and now lives in San Francisco. For a discussion of California assemblage artists see *Forty Years of California Assemblage*, exhibition catalogue (Los Angeles: Wight Art Gallery, University of California, 1989).

[5] See Mike Gunderloy and Cari Goldberg Janice, *The World of Zines: A Guide to the Independent Magazine Revolution* (New York: Penguin Books, 1992). Current feminist literary criticism has also informed Murray's choice of alternative forms of publication. See Susan Howe, *The Birth-Mark: Unsettling the Wilderness in American Literary History* (Hanover, N.H.: University Press of New England, 1993); Martha Nell Smith, *Rowing in Eden: Rereading Emily Dickinson* (Austin: University of Texas Press, 1992); and Jean Holland, "Scraps, Stamps, and Cutouts: Emily Dickinson's Domestic Technologies of Publication," in *Cultural Artifacts and the Production of Meaning, the Page, the Image, and the Body*, ed. Margaret J.M. Ezell and Katherine O'Keeffe (Ann Arbor: University of Michigan Press, 1994), 139-81.

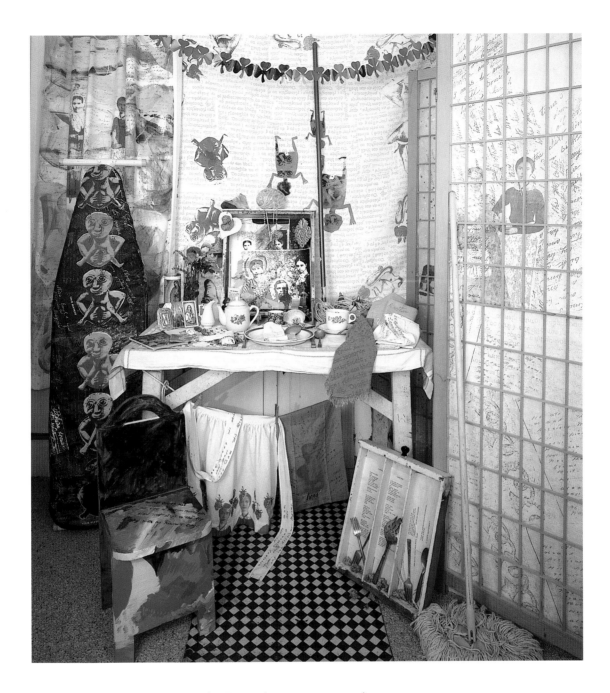

The Lamp burns sure—within—
Tho' Serfs—supply the Oil—
It matters not the busy Wick—
At her phosphoric toil!

The Slave—forgets—to fill—
The Lamp—burns golden—on—
Unconscious that the oil is out—
As that the Slave—is gone.

(P 233)

Barbara Penn

(b. 1952)

Plate 15

"Make the Yellow to the Pies," 1993

Mixed media installation

108 x 144 x 132 in.

Collection of the artist

A PROLIFIC LETTER WRITER throughout her life, Emily Dickinson often included poetic phrases and poems in her correspondence. Barbara Penn has selected one such oblique reference to Dickinson's love of baking as the literary source for a large-scale installation that includes pie plates, honey combs, and eggs. In a statement about this work, Penn notes that although Dickinson abhorred housework in general, she enjoyed concocting elaborate desserts and making bread (especially proofing or punching down the risen dough).[1] The tension between nineteenth-century norms of domesticity and Dickinson's opposition to those constraints, which she expressed through poetry and baking, provides the basis for Penn's art. The outward sense of control and organization that is apparent in this piece, with its gridwork of beeswax boxes, cratelike containers of fragile plaster eggs, and tidy stacks of rolling-pin shaped cylinders, suggests the subtle balance in Dickinson's poems between the precarious and the well-ordered aspects of life.

Such visual references to order and control also relate to appearance and meaning in the poems. Throughout her mature years, Dickinson resisted the publication of her handwritten work. She feared (and rightly so) that editors would regularize her purposively eccentric grammar, syntax, and punctuation, stripping away the finely honed sense of poetic ambiguity.[2] All of Penn's Dickinson works incorporate enigmatic objects that also elicit a heightened sense of ambiguity. Those that include samples of the poet's script, such as *"+ too + swelling + fitter for,"* concentrate on language as a visual object, which Penn notes is the element of Dickinson's "poetic expression that [has] been devalued over time."[3]

Penn began her artistic career as a painter, studying art with Louise Stanley at the San Francisco Art Institute and with Joan Brown and Elmer Bischoff at the University of California at Berkeley. Her current work, which combines visual forms of poetic expression, feminist issues, and the art of assemblage, relates to her early years in California, as well as to a more recent residency at Yaddo, the artists' and writers' colony near Saratoga Springs, New York. Penn's association with Dickinson is further fueled by the memory of her grandmother's Victorian house in upstate New York, which was "full of private passages and unlikely treasures." An unpublished poet like Dickinson, Penn's grandmother serves as a point of reference for the intersection of painting, poetry, and personal history in the artist's own work: "Like poetry and painting, art as installation can in most simple terms be about space, meter, and being—a condition where solitude, contemplation, conjecture and matter all merge into a wellspring of interpretations."[4]

[1] See artist's statement, in the Emily Dickinson exhibition files, Mead Art Museum. This statement accompanied the piece when it was installed at the Scottsdale Center for the Arts, Scottsdale, Arizona, in 1993. It was also shown at Artemisia Gallery in Chicago, 3-27 January 1996.

[2] Penn is a careful reader of Dickinson texts and often refers to the *Manuscript Books of Emily Dickinson*, 2 vols., ed. Ralph Franklin (Cambridge, Mass.: Belknap Press, 1981). She also acknowledges a debt to the critical writing of the poet Susan Howe, with whom she collaborated at the Tucson Poetry Festival, 14-17 April 1994. For a recent summary of the changing critical approaches toward the integrity of Dickinson's handwritten poems and printed texts, see Margaret Dickie, "Dickinson in Context," *American Literary History* 7 (Summer 1995): 320-33.

[3] From an artist's statement about the work, September 1995, copy in exhibition file, Mead Art Museum. Other recent works by Penn that include Dickinson's handwriting are *1210, The Sea said "Come" to the Brook—* (1994) and *728, Let Us play Yesterday* (1995).

[4] Artist's statement, September 1995, for the installation *Science, Symbol, and Verse: Chronicles of Past and Present*, University Art Museum, Tucson, Arizona, copy in exhibition file, Mead Art Museum. Penn is presently an assistant professor of painting and drawing at the University of Arizona.

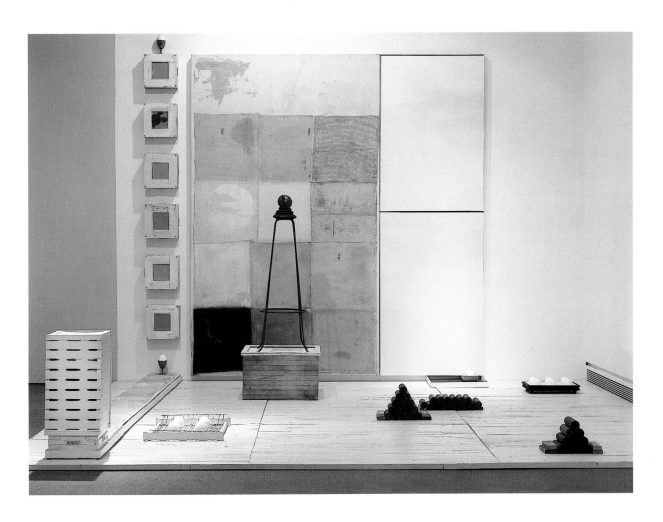

"I make the yellow to the pies, and bang the spice for the cake. . . .
They say I am a help."

(L 302)

Linda Schwalen

(b. 1943)

Plate 16

Poem No. 754—"My Life had stood a Loaded Gun," 1995

Oil and graphite on paper

38 x 25 in.

Collection of the artist

LINDA SCHWALEN'S COMPLEXLY INTERTWINED stencil-letter drawings convert Dickinson's readable text into abstract visual form. They pointedly make the legible illegible. In her drawings, Schwalen adopts a form of script often employed by nineteenth-century letter writers to save on postage.[1] The text is written both horizontally and vertically, making the individual lines difficult to decipher. Schwalen thus produces an image in which, as she says, "words appear and disappear, forming and re-forming. This is intended to provide a visual metaphor for the task and dilemma of the Dickinson reader. As one penetrates the modest surface of the poem, one watches a world of quotidian details expand."[2] Schwalen's notion of the expanding world also relates to the unusual artistic medium that she employs in making these drawings— graphite and used motor oil. Over time, this viscous medium continues to seep into the paper, thickening some lines and giving contrast to others. As a result, individual words and shapes stand out in relief against a background of interwoven letters.

In her artist's books of Dickinson poems, Schwalen also inscribes the text in a similar fashion on the inside of the book covers, which are, like the motor oil, recycled. These small, intricately designed book covers once surrounded the pages of popular German novels, from which Schwalen has torn out the original texts, obscured the old titles, and added small polaroid landscape photographs. In the process, she turns the book into a sculptural object, an object with a history, full of oblique references to the natural world, not unlike a Dickinson poem. A recent transplant to New England, Schwalen originally sought out the poetry of the region as a means of immersing herself in the culture of a new place.[3] She is also an avid reader of Melville, Hawthorne, and Stevens, but it is, as she has said, "the cryptic combination of compression and expansion in Dickinson's poems" that is best suited as the text for her letter drawings.

Cristanne Miller's writings about Dickinson's use of language have also been a significant influence on Schwalen's choice of texts. The critic notes that "My Life had stood—a Loaded Gun" is "the most frequently and extensively explicated of Dickinson's poems" because it is capable of producing a multiplicity of meaning.[4] The contradiction between Dickinson's open-ended ambiguity and her use of compacted language makes these poems fertile ground for contemporary visual artists like Schwalen.

[1] For example see Milton Rugoff, *The Beechers: An American Family in the Nineteenth Century* (New York: Harper and Row, 1981), 602-3.

[2] Artist's statement, September 1995, in the Emily Dickinson exhibition file, Mead Art Museum.

[3] Trained at the Minneapolis Institute of Art, Schwalen now works in North Bennington, Vermont. Comments from a conversation with the artist in September 1995.

[4] Cristanne Miller, *Emily Dickinson: A Poet's Grammar* (Cambridge: Harvard University Press, 1987), 122-23.

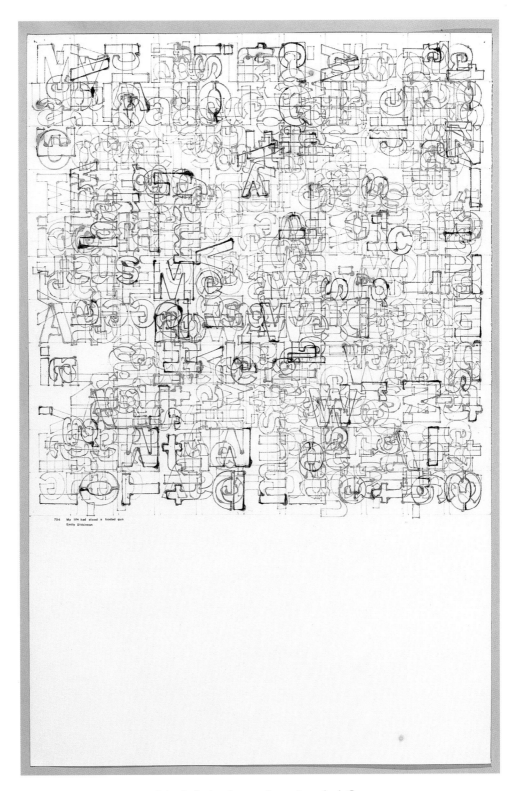

My Life had stood—a Loaded Gun—
In Corners—till a Day
The Owner passed—identified—
And carried Me away—

(P 754)

Exhibition Checklist

Language as Object

Will Barnet (b. 1911)
Combing, 1990
["When Night is almost done," Poem No. 347]
Oil on canvas
22 x 31 in.
Collection of the artist

The Glass, 1990-91
["Between the form of Life and Life,"
Poem No. 1101]
1990-91
Oil on canvas
21 1/2 x 23 1/2 in.
Collection of the artist

Judy Chicago (b. 1939)
Emily Dickinson Plate (Model for the *Dinner Party*),
1979
Lace and hand-painted ceramic
14 in. diam.
Mead Art Museum
Gift of J. Thomas Harp

Illuminated Letter for Emily Dickinson, 1979
Ink, watercolor, and ribbon embroidery on paper
7 1/4 x 11 1/2 in.
Mead Art Museum
Gift of Constance Matthiessen von Briesen in
memory of her mother, Madge McCormack
Matthiessen

Joseph Cornell (1903-1972)
"Toward the Blue Peninsula" (for Emily Dickinson),
1953
Mixed media
14 1/2 x 10 1/4 x 5 1/2 in.
Collection of Mr. and Mrs. Robert Lehrman,
Washington, D.C.

Chocolat Menier, 1952
Mixed media
17 x 12 x 4 3/4 in.
Grey Art Gallery and Study Center, New York
University Art Collection
Anonymous Gift, 1966

Hotel Box, ca. 1953-55
Mixed media
16 1/2 x 10 x 3 in.
Mead Art Museum
Gift of the C and B Foundation

Gold Ball Box, 1959
Mixed media
8 1/4 x 9 x 6 in.
National Museum of American Art,
Smithsonian Institution, Joseph Cornell Study
Center, Gift of Mr. and Mrs. John A. Benton

2 Packets of Bundled Papers, undated
National Museum of American Art,
Smithsonian Institution, Joseph Cornell Study
Center, Gift of Mr. and Mrs. John A. Benton

Manuscript Page with Notes on Emily Dickinson,
1952-53
(with excerpt from Rebecca Patterson's
The Riddle of Emily Dickinson, 1951)
National Museum of American Art,
Smithsonian Institution, Joseph Cornell Study
Center, Gift of Mr. and Mrs. John A. Benton

Postcard of Dickinson House
(sent to Cornell by his mother, postmarked
1951)
National Museum of American Art,
Smithsonian Institution, Joseph Cornell Study
Center, Gift of Mr. and Mrs. John A. Benton

Dance Index 3 (July-Aug. 1944)
(edited by Joseph Cornell)
National Museum of American Art,
Smithsonian Institution, Joseph Cornell Study
Center, Gift of Mr. and Mrs. John A. Benton

Robert Cumming (b. 1943)
Smooth Mind, Eye Content, Upon the Head, Knowing/ Not Seeing, 1989
Set of four lithographs
27 x 22 in. (each)
Collection of the artist

Lesley Dill (b. 1950)
Paper Poem Torso, 1993
["Exhilaration is within," Poem No. 383]
Mixed media on rice paper
136 x 20 x 4 in.
Smith College Museum of Art, Northampton,
Massachusetts, Purchased, Janet Wright
Ketcham '53 Fund, 1994

Poem Swallow, 1993
["A Secret told," Poem No. 381]
Copper and wire
252 x 5 in. (variable)
Courtesy of George Adams Gallery, New York

White Poem Dress, 1993
["This World is not Conclusion," Poem No. 501]
Painted metal and plaster
55 x 36 x 30 in.
Private Collection

Word Made Flesh (Front, Back, Throat, Arms), 1994
Set of four photolithographs with etching, on
tea-stained Japanese mulberry paper, sewn with
blue thread
29 x 22 in. (each)
Mead Art Museum
Museum Purchase

Poem Hands (Double), "Palpé mi vida, con dos mi manos," 1995
["I felt my life with both my hands," Poem No. 351]
Ink, tea, oil paint, shellac, thread, and wire on
gauze
309 x 41 in.
Courtesy of George Adams Gallery, New York

Rolled Up Poem Girl, 1995
["I took my Power in my Hand," Poem No. 540]
Acrylic, oil paint, thread, and wire on tea-
stained muslin
156 x 45 in.
Courtesy of George Adams Gallery, New York

Mary Frank (b. 1933)
Person and Mountain, 1994
["Blazing in Gold and quenching in Purple," Poem No. 228]
Cut paper
8 1/4 x 9 1/4 in.
Elena Zang Gallery

Woman and Bird, 1994
["A Bird came down the Walk," Poem No. 328]
Cut paper
8 1/4 x 8 1/2 in.
Elena Zang Gallery

Woman and Landscape, 1994
["Like Men and Women Shadows walk," Poem No. 1105]
Cut paper
8 1/4 x 11 3/4 in.
Elena Zang Gallery

Head in Hand, 1994
["A Spider sewed at Night," Poem No. 1138]
Cut paper
Elena Zang Gallery

Trees, 1994
["The Day grew small, surrounded tight," Poem No. 1140]
Cut paper
8 1/4 x 11 3/4 in.
Elena Zang Gallery

Wind, 1994
["Like Rain it sounded till it curved," Poem No.1235]
Cut paper
10 3/4 x 12 in.
Elena Zang Gallery

Head in Fish, 1994
["'Go Traveling with us!'" Poem No. 1513]
Cut paper
8 1/4 x 12 in.
Elena Zang Gallery

Crow, 1994
["No Brigadier throughout the Year,"
Poem No. 1561]
Cut paper
11 1/2 x 17 in.
Elena Zang Gallery

Roni Horn (b. 1955)
How Dickinson Stayed Home, 1992-93
Plastic and aluminum, "3/3"
5 in. x 23 ft. x 16 ft.
Dimensions variable, museum installation
The Museum of Modern Art
Gift of Agnes Gund, 1993

Carla Rae Johnson (b. 1947)
Lectern for Emily Dickinson, 1994
Wood and mixed media
89 x 54 x 64 in.
Collection of the artist

Paul Katz (b. 1942)
I reason, Earth is short, 1993
Oil and sand on canvas
30 x 30 in.
Collection of the artist

The Soul Selects Her Own Society, 1993
Oil and sand on canvas
28 x 28 in.
Collection of the artist

The Loneliness One Dare Not Sound, 1993
Oil and sand on canvas
26 x 26 in.
Collection of the artist

Through the Strait Pass of Suffering, 1993
Oil and sand on canvas
24 x 24 in.
Collection of the artist

I Dwell in Possibility, 1993
Oil and sand on canvas
22 x 22 in.
Collection of the artist

I Died for Beauty, 1993
Oil and sand on canvas
20 x 20 in.
Collection of the artist

Barbara Morgan (1900-1992)
Letter to the World (Finale), 1940
Gelatin silver print
11 x 14 in.
Amon Carter Museum, Fort Worth

Letter to the World (Swirl), 1940
Photographic mural
48 x 53 in.
Amon Carter Museum, Fort Worth

Letter to the World (Kick), 1940
Gelatin silver print
15 1/4 x 19 1/2 in.
Smith College Museum of Art,
Northampton, Massachusetts
Purchased with the aid of funds from the
National Endowment for the Arts, 1977

Aífe Murray (b. 1953)
Pantry DRAWer, 1993-95
Mixed media and collage
64 x 42 x 22 in.
Collection of the artist

Barbara Penn (b. 1952)
"I Make the Yellow to the Pies," 1993
Mixed media installation
108 x 144 x 132 in.
Collection of the artist

"+ too + swelling + fitter for," 1994
Mixed media installation
36 x 48 x 6 in.
Collection of the artist

Poem No. 39 "She will stir her pinions," 1994
Mixed media installation
146 x 84 x 48 in.
Collection of the artist

*Poem No. 341 "After great pain, a formal
feeling comes,"* 1994
Mixed media installation
120 x 146 x 146 in.
Collection of the artist

Letters on Practical Subjects, 1995
Mixed media installation
108 x 312 x 36 in.
Collection of the artist

Linda Schwalen (b. 1943)
Poem No. 512 "The soul has bandaged moments," 1995
Oil and graphite on paper
38 x 25 in.
Collection of the artist

Poem No. 754 "My Life had stood a Loaded Gun," 1995
Oil and graphite on paper
38 x 25 in.
Collection of the artist

Artist's Books

Paul Katz (b. 1942)
Trees, 1993
Collection of the artist

Clouds, 1993
Collection of the artist

Linda Schwalen (b. 1943)
Poem No. 211 "Come Slowly—Eden!" 1995
Poem No. 528 "Mine—by the Right of the White Election!" 1995
Poem No. 581 "I found the words to every thought," 1995
Poem No. 675 "Essentials Oils—are wrung—," 1995
Collection of the artist

Anne Walker (b. 1933)
A Pumpkin Field for Emily Dickinson, 1989
Collection of Robert Herbert

February Hour, 1992
Neilson Rare Book Collection, Smith College

Images of Emily Dickinson

Charles Temple (1824-1906)
Emily Dickinson, 1845
Cut paper silhouette
Amherst College Library

Attributed to Otis H. Cooley (act. 1844-55)
Emily Dickinson, ca.1847
Daguerreotype
Amherst College Library

Unidentified Artist
Emily Dickinson, 1893
Pencil on paper
The Todd-Bingham Picture Collection,
Manuscripts and Archives,
Yale University Library

Laura Coombs Hills (1859-1952)
Emily Dickinson, 1897
Photograph with gouache
Emily Dickinson Collection,
Houghton Library, Harvard University

Barbara Swan (b. 1922)
Emily Dickinson, ca. 1961-63
Lithograph
Dickinson Homestead, Amherst College

Oriole Farb Feshbach (b. 1931)
Emily Dickinson / Amy Clampitt, 1992
Pastel and collage on paper
Collection of the artist

Nancy Burson (b. 1948)
Emily Dickinson, at Age 52, 1995
Computer-generated silver print
Mead Art Museum
Museum Purchase

Icons of Emily Dickinson

Lock of Emily Dickinson's Hair
Amherst College Library, Special Collections

Unidentified Maker
(American, mid-19th Century)
White Dress
Cotton damask
Courtesy of the Amherst History Museum
at the Strong House, Amherst, Mass.

Jerome Liebling (b. 1924)
Basket at Window in Emily Dickinson's Bedroom, 1980
Chromogenic color photograph
Collection of the artist

Fence between the Dickinson Homestead and the Evergreens, 1982
Chromogenic color photograph
Collection of the artist

Emily Dickinson's Gravestone, 1985
Chromogenic color photograph
Collection of the artist

Emily Dickinson's Chair, Houghton Library,
Harvard University, 1992
Chromogenic color photograph
Collection of the artist

Emily Dickinson's Desk, Houghton Library,
Harvard University, 1992
Chromogenic color photograph
Collection of the artist

Dickinson Homestead, from the east, 1992
Chromogenic color photograph
Collection of the artist

View of the Evergreens from the Dickinson Homestead,
1992
Chromogenic color photograph
Collection of the artist

Emily Dickinson's Bedroom, 1993
Chromogenic color photograph
Collection of the artist

Emily Dickinson
and Popular Culture

Postage Stamp
United States Eight-Cent Stamp
First Day Issue, 28 August 1971

Trading Cards
Emily Dickinson Major League Poet Cards
Mille Grazie Press, Santa Monica, Calif.

Card Game
Great Women Poets and Writers
Artistoplay, Ltd., Ann Arbor, Mich.

Poster
"Hope is the Thing with Feathers"
New York Transit Authority,
Poetry in Motion Series, ca. 1993

Poster
Emily Dickinson—a celebration
Plymouth Arts Centre, 18-22 May 1993
Poster
Emily Dickinson Abroad
2nd International Conference of the Emily
Dickinson International Society, 4-6 August
1995

T-Shirt
Designed by CBagg, 1989
Largely Literary Ts

T-Shirt
Sophisticated Shirts
Indianapolis, Ind.

T-Shirt
Designed for 2nd International Conference of
the Emily Dickinson International Society,
1995

AIDS Ribbon Advertisement
"I'll tell you how the Sun rose
—A Ribbon at a Time—"
The National AIDS Awareness Catalogue,
1995

Public Service Announcement
"Books Change Minds," The Boston Public Library
Designed by Arnold Advertising for the Boston
Globe, 7 July 1995

Emily Dickinson Look-A-Like Contest
Sponsored by the Book and the Plow Festival
Press photograph published in the
Daily Hampshire Gazette, 16 October 1995

Belle of Amherst
Press photograph for Tony Award winning
production of play with Julie Harris, 1977

Playbill
Emily Unplugged
Presented by the Sleeveless Theatre,
16-19 November 1995
Hampden Theatre,
University of Massachusetts

Selected Bibliography

The following bibliography provides the reader with a general introduction to the life and work of Emily Dickinson, as well as an overview of the literary criticism related to her poetry. For references to the relationship between Dickinson and specific artists, please see individual catalogue entries.

Anderson, Charles Robert. *Emily Dickinson's Poetry: Stairway of Surprise*. New York: Holt, Rinehart and Winston, 1960.

Benfey, Christopher. *Emily Dickinson: Lives of a Poet*. New York: George Braziller, Inc., 1986.

————. *Emily Dickinson and the Problems of Others*. Amherst: University of Massachusetts Press, 1984.

————. "A World in a Frame." In *A World in a Frame: Drawings by Will Barnet, Poems by Emily Dickinson*, vii-xiv. New York: George Braziller, Inc., 1989.

Blake, Caesar R., and Carlton F. Wells, eds. *The Recognition of Emily Dickinson: Selected Criticism Since 1890*. Ann Arbor: University of Michigan Press, 1964.

Cameron, Sharon. *Choosing Not Choosing: Dickinson's Fascicles*. Chicago: University of Chicago Press, 1992.

————. *Lyric Time: Dickinson and the Limits of Genre*. Baltimore: Johns Hopkins University Press, 1979.

Capps, Jack L. *Emily Dickinson's Reading, 1836-1886*. Cambridge: Harvard University Press, 1966.

Dickie, Margaret. "Dickinson in Context." *American Literary History* 7 (Summer 1995): 320-33.

Dickinson, Emily. *Bolts of Melody: New Poems by Emily Dickinson*. Edited by Mabel Loomis Todd and Millicent Todd Bingham. New York: Harper and Brothers, 1945.

————. *The Letters of Emily Dickinson*. 3 vols. Edited by Thomas H. Johnson and Theodora Ward. Cambridge: Harvard University Press, 1958.

————. *The Manuscript Books of Emily Dickinson*. 2 vols. Edited by Ralph Franklin. Cambridge: Harvard University Press, 1981.

————. *Poems by Emily Dickinson*, Third Series. Edited by Mabel Loomis Todd. Boston: Little Brown, 1896.

————. *The Poems of Emily Dickinson*. 3 vols. Edited by Thomas H. Johnson. Cambridge, Mass.: Harvard University Press, 1955.

Dobson, Joanne. *Dickinson and the Strategies of Reticence: The Woman Writer in Nineteenth-Century America*. Bloomington: Indiana University Press, 1989.

Erkkila, Betsy. *The Wicked Sisters: Women Poets, Literary History, and Discord*. New York: Oxford University Press, 1992.

Farr, Judith. "Disclosing Pictures: Emily Dickinson's Quotations from the Paintings of Thomas Cole, Frederic Church, and Holman Hunt." *Emily Dickinson Journal* 2, no. 2 (1993): 66-77.

————. *The Passion of Emily Dickinson*. Cambridge: Harvard University Press, 1992.

Franklin, Ralph. *The Editing of Emily Dickinson: A Reconsideration*. Madison: University of Wisconsin Press, 1967.

Gelpi, Albert. *Emily Dickinson: The Mind of the Poet*. Cambridge: Harvard University Press, 1965.

Homans, Margaret. *Women Writers and Poetic Identity: Dorothy Wordsworth, Emily Bronte, and Emily Dickinson*. Princeton: Princeton University Press, 1980.

Howe, Susan. *The Birth-Mark: Unsettling the Wilderness in American Literary History*. Hanover, N.H.: University Press of New England, 1993.

————. *My Emily Dickinson*. Berkeley: North Atlantic Books, 1985.

Johnson, Thomas Herbert. *Emily Dickinson: An Interpretive Biography*. Cambridge, Mass.: Belknap Press, 1955.

Juhasz, Suzanne. *The Undiscovered Continent: Emily Dickinson and the Space of the Mind*. Bloomington: Indiana University Press, 1983.

————, Cristanne Miller, and Martha Nell Smith, eds. *Comic Power in Emily Dickinson*. Austin: University of Texas Press, 1993.

Keller, Karl. *The Only Kangaroo among the Beauty: Emily Dickinson and America*. Baltimore: Johns Hopkins University Press, 1979.

Leyda, Jay. "Miss Emily's Maggie." *New World Writing* 3 (1953): 255-67.

————. *The Years and Hours of Emily Dickinson*. 2 vols. New Haven: Yale University Press, 1960.

Loeffelholz, Mary. *Dickinson and the Boundaries of Feminist Theory*. Urbana: University of Illinois Press, 1991.

Longsworth, Polly. *Austin and Mabel: The Amherst Affair and Love Letters of Austin Dickinson and Mabel Loomis Todd*. New York: Farrar, Straus and Giroux, 1984.

————. *The World of Emily Dickinson*. New York: W.W. Norton and Co., 1990.

Lubbers, Klaus. *Emily Dickinson: The Critical Revolution*. Ann Arbor: University of Michigan Press, 1968.

McGann, Jerome. *Black Riders: The Visible Language of Modernism*. Princeton: Princeton University Press, 1993.

MacLeish, Archibald, Louis Bogan, and Richard Wilbur. *Emily Dickinson: Three Views*. Amherst, Mass.: Amherst College Press, 1960.

McNeil, Helen. *Emily Dickinson*. New York: Pantheon Books, 1986.

Mossberg, Barbara Antonina Clarke. *Emily Dickinson: When a Writer Is a Daughter*. Bloomington: Indiana University Press, 1982.

Mudge, Jean McClure. *Emily Dickinson and the Image of Home*. Amherst: University of Massachusetts Press, 1975.

Pollak, Vivian R. *Dickinson, the Anxiety of Gender*. Ithaca: Cornell University Press, 1984.

Porter, David. *The Art of Emily Dickinson's Early Poetry*. Cambridge: Harvard University Press, 1966.

————. *Dickinson: The Modern Idiom*. Cambridge: Harvard University Press, 1981.

St. Armand, Barton Levi. *Emily Dickinson and Her Culture: The Soul's Society*. New York: Cambridge University Press, 1984.

Sánchez-Eppler, Karen. Review of *Dickinson and the Boundaries of Feminist Theory*, by Mary Loeffelholz. *American Literature* 64 (Sept. 1992): 607.

————. *Touching Liberty: Abolition, Feminism and the Politics of the Body*. Berkeley: University of California Press, 1993.

Sewall, Richard B. *The Life of Emily Dickinson*. New York: Farrar, Straus and Giroux, 1974.

Smith, Martha Nell. *Rowing in Eden: Rereading Emily Dickinson*. Austin: University of Texas Press, 1992.

Weisbuch, Robert. *Emily Dickinson's Poetry*. Chicago: University of Chicago Press, 1975.

Wolff, Cynthia Griffin. *Emily Dickinson*. New York: Alfred Knopf, 1986.

Photography Credits